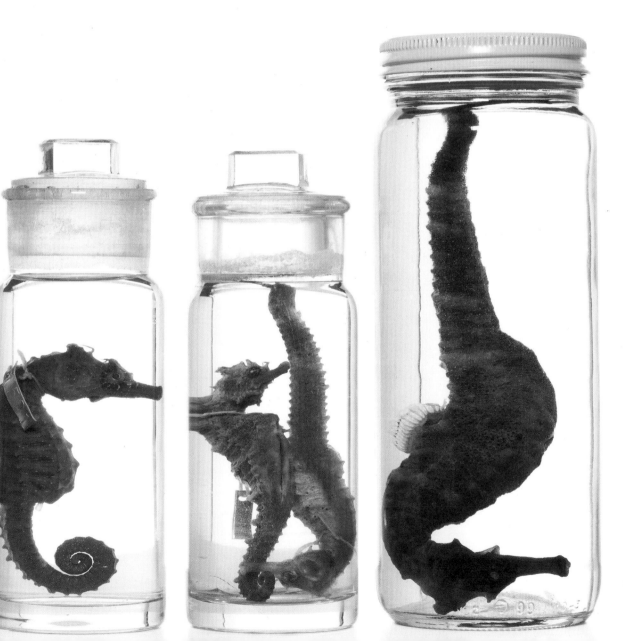

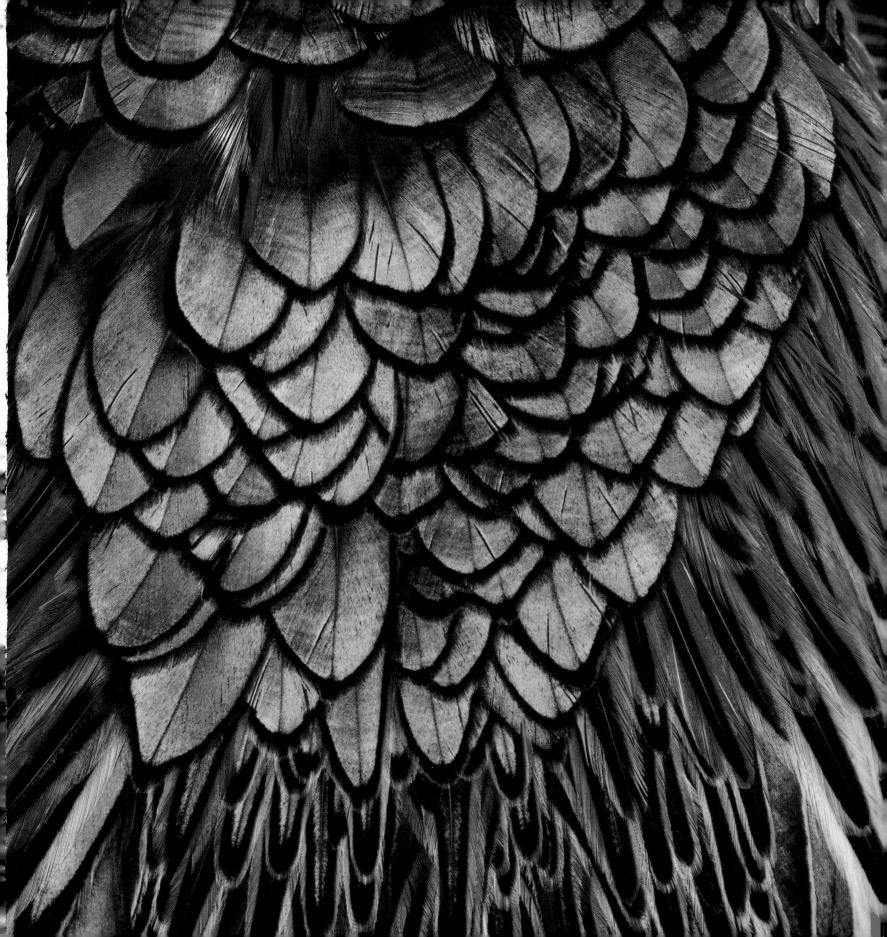

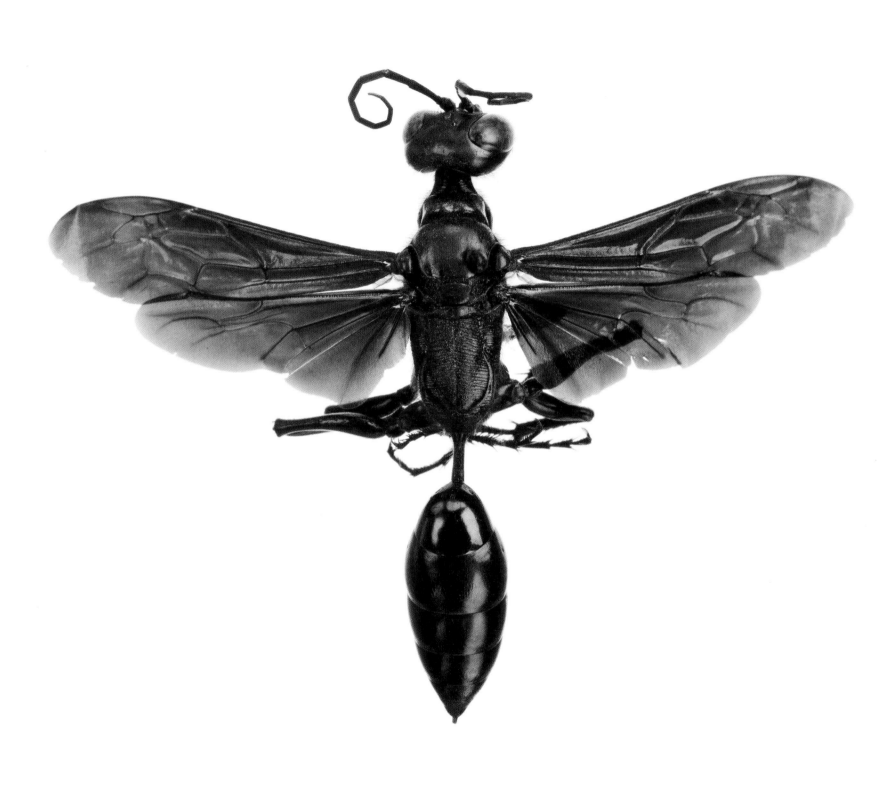

EVIDENCE OF
EVOLUTION

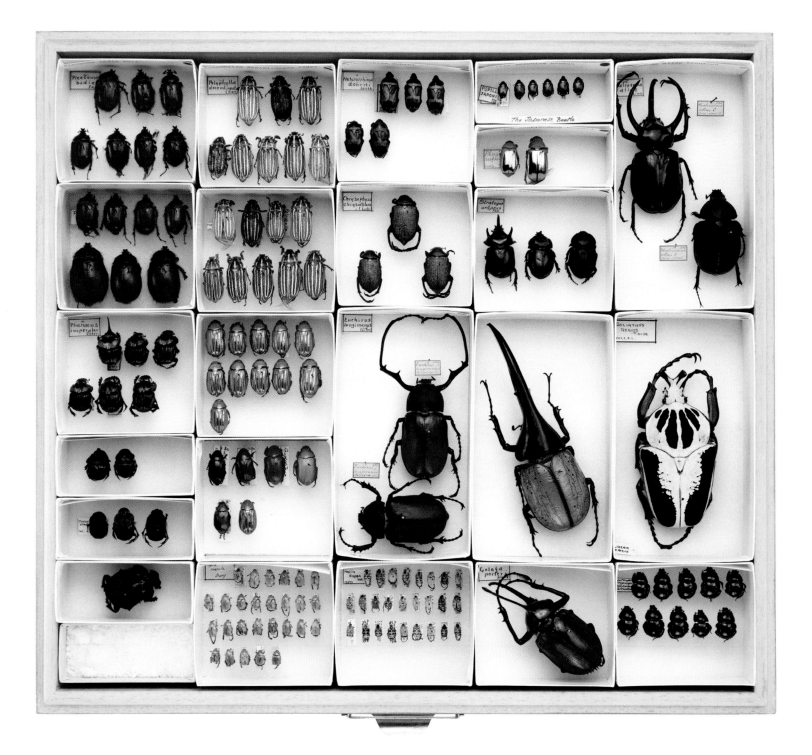

EVIDENCE OF
EVOLUTION

photography by SUSAN MIDDLETON *text by* MARY ELLEN HANNIBAL

ABRAMS, NEW YORK

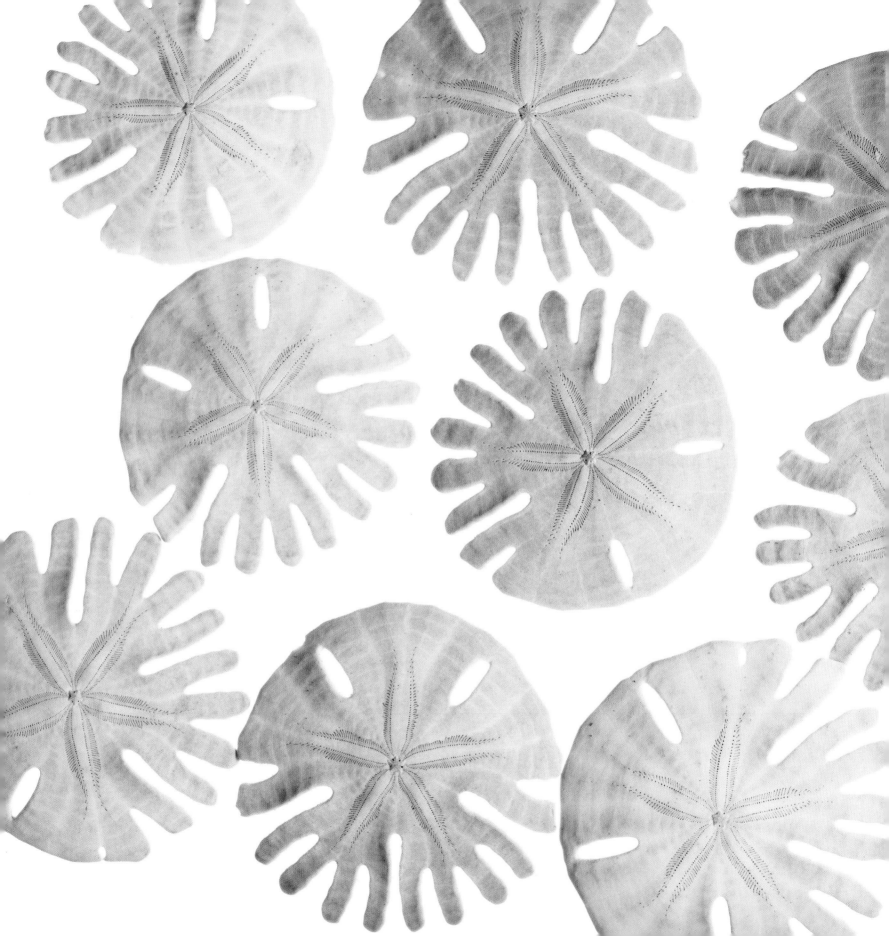

To Robert J. Bettencourt
—SM

To Richard, Eva, and Nick, evidence of my own evolution
—MEH

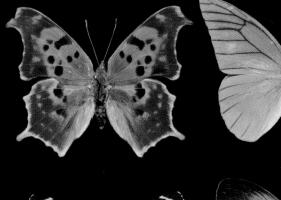
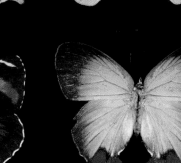
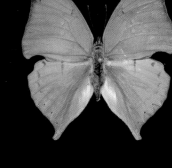

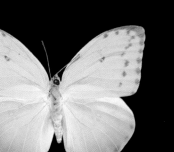
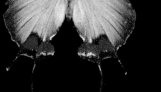
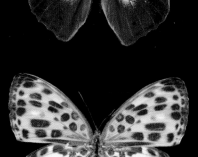
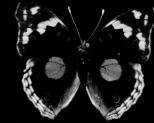

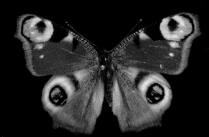
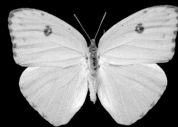
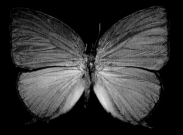
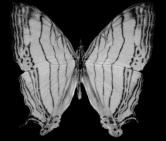

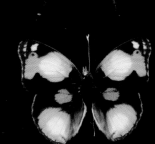
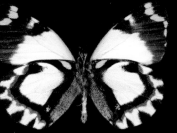

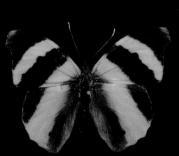

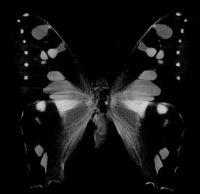

CONTENTS

Opposite: Nature has been a careful couturier in the case of the butterfly; the four stages of metamorphosis between embryo and adult provide staging areas for developmental pathways to invent, elaborate, and organize features like eyespots, bands, and colors.

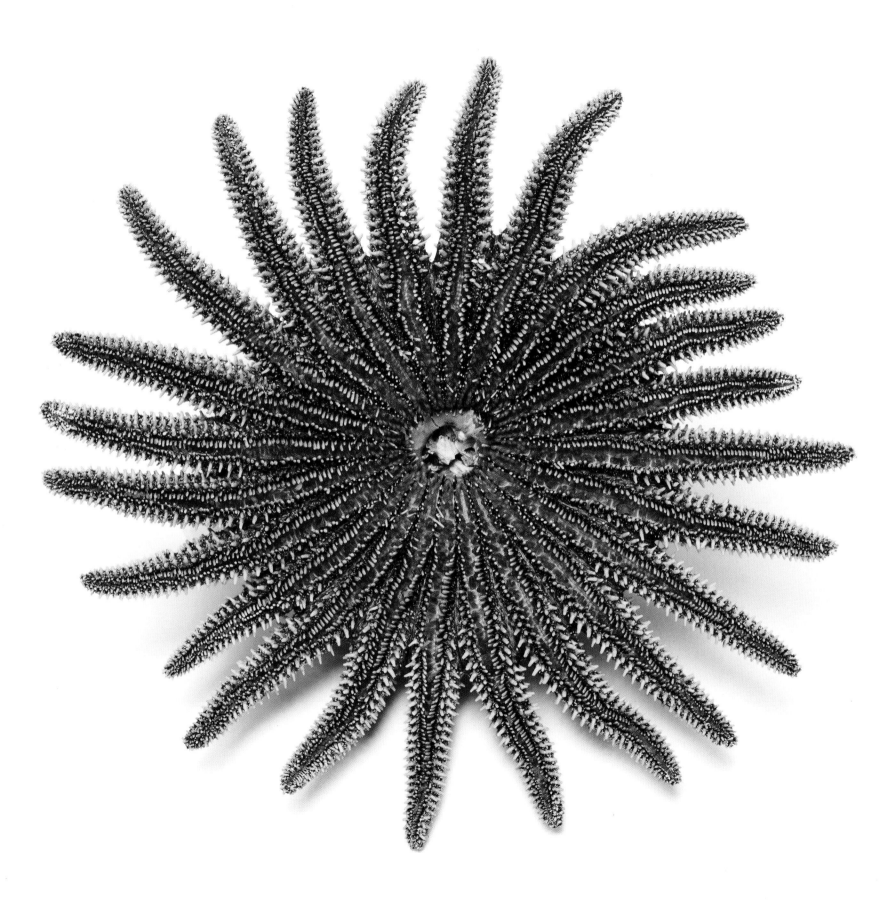

INTRODUCTION

Why do butterfly wings have so many different patterns, and if a snake is a reptile and an eel a fish, why do they look so similar? A hundred and fifty years ago, Charles Darwin addressed these questions with the publication of his seminal work, *On the Origin of Species*. In it, Darwin posited the theory of evolution based on natural selection as the answer. He proposed that descent with modification over time leads to new forms of life. According to his theory, butterflies gradually adopted traits such as wing patterning in service of eluding predators and attracting a mate. Similarly, both snakes and eels have capitalized on one of nature's most successful body plans, which works by land and by sea. Flexing, undulating, burrowing, and moving in and out of tight spaces—the sleek form facilitates swimming, whether in water or through grass. Today, most scientists would say that evidence of evolution is all around us; that as the central mechanism of life there is no way to understand the world without it. And science is now engaged with studying evolution as never before, because understanding the hows and whys of the Earth's history is the foundation for understanding our future, and ensuring that we will indeed have one. Modern scientists use techniques Darwin never dreamed of to parse out the story of life, grinding genetic material and entering its data into computer programs to yield the secrets encoded in DNA. But they are equally reliant on tradition that Darwin knew well—taxonomy.

Taxonomy—from the Greek *taxis*, "arrangement," and *nomos*, "law"—is nothing less than the classification of all living things, a vast and ever-increasing filing system. By identifying and naming species, scientists place them in relation to other organisms and thus define patterns of evolution, or systematics. And the first step in determining what exactly an organism is, and where it belongs in relation to other organisms, is to "collect" it. Specimen in hand, scientists can begin to compare it to others of its apparent kind by examining its morphology, or physical traits.

Thus do specimens in natural history museums inform the long conversation and drive the discovery process of science. Millions upon millions of them; beetles, butterflies, tortoises, birds, and fossils of everything from bacteria to dinosaurs, lie in temperature-controlled trays on enormous metal compactors, hidden from public view behind the dioramas and the exhibits (or sequestered on another floor)—scientists continue to collect a mind-boggling array of the treasures of life. Tiny ants are fastidiously mounted, along with documentation in minuscule script. Fish and reptiles are suspended in alcohol, the jar lids screwed on tight. Other specimens are simply tucked away, neatly, like sweaters in a drawer. These various displays are ways of preserving information.

Yet, confronted with more than two million beetle specimens alone at the California Academy of Sciences in San Francisco, where the photographs for this book were made, one might very well ask, "When is it enough?" And indeed, in our conservation-minded world, especially among scientists whose ultimate goal is the full appreciation of their subject, care is taken not to over-collect. Gone are the days when explorers stuffed as many tortoises as they could into the holds of their ships. But based on physical examples, how many would it take to represent the human being? You would certainly need one of each sex of every race, and all the combina-tions found in the world thereof, to say nothing of body types, blood types, hair and eye color differences, and so on. And if you wanted to understand exactly how *Homo sapiens* came to look and behave the way we do now, you would have to have examples from every previous incarnation of our species. Still, our individual experience of being human goes well beyond our body type, race, sex, and place in time. Taxonomists strive to develop broad, deep collections that will together create an accurate picture of nature and its relationships, but they must balance this quest with ecologically responsible practices.

All a far cry from the antecedents of today's natural history museums, which can be traced to the private "curiosity cabinets"

of the seventeenth and eighteenth centuries. For hundreds of years thereafter, amateur collectors amassed souvenirs, both beautiful and strange; it was not unusual for an opulent domicile in sixteenth- and seventeenth-century Western Europe to house the equivalent of its own museum. (Even today, personal collections arrive at the doors of natural history museums, and sometimes these have valuable components: unexpected fossils, for example, or a prime example of indigenous art.) Peter the Great of Russia was one of the first to display his, in 1710; the collection included the pickled heads of his lover and his wife's lover. Now that says something about *Homo sapiens*.

At the same time, early scholars sought to identify, describe, and connect the links among organisms to create a vast hierarchy and re-create the Great Chain of Being. The Royal Society established the unifying principle of modern scientific institutions in 1660 based on Francis Bacon's idea that separate collected objects could be compared and analyzed toward "the knowledge of causes." *Cause* is a persistent bone of cultural, if not scientific, contention; though nobody knows why, or precisely how, life on Earth was instigated, a very detailed history of how it has progressed is being ever more deeply established. The relationships among even drastically disparate organisms, the genealogies that connect the most ancient organisms with groups alive today, is evolution.

Previous spread, left: Starfish are not fish, but echinoderms (from the Greek for "spiny skin"); their number of arms ranges from five to even more than the whopping twenty-four in this species. Tube feet cover the underside of their arms and have sticky suckers at their ends, which can be used for locomotion or to manipulate objects, including food. When it comes time for the starfish to eat, it simply everts its stomach over its prey and begins digesting.

Opposite: Moths seek camouflage when they rest, lying flat against a tree trunk or another obscuring surface. Butterflies fold their wings over their backs, hiding their glory. In contrast to most moths, which are drab, this atlas moth, *Attacus edwardsii*, displays a quiet beauty.

Overleaf: Amphibians, including these salamanders, frogs, and legless schistometopums, are found everywhere on Earth except in the Arctic. Because they bridge two worlds, land and water, and have highly permeable skin, they are good indicators of the health of an ecosystem.

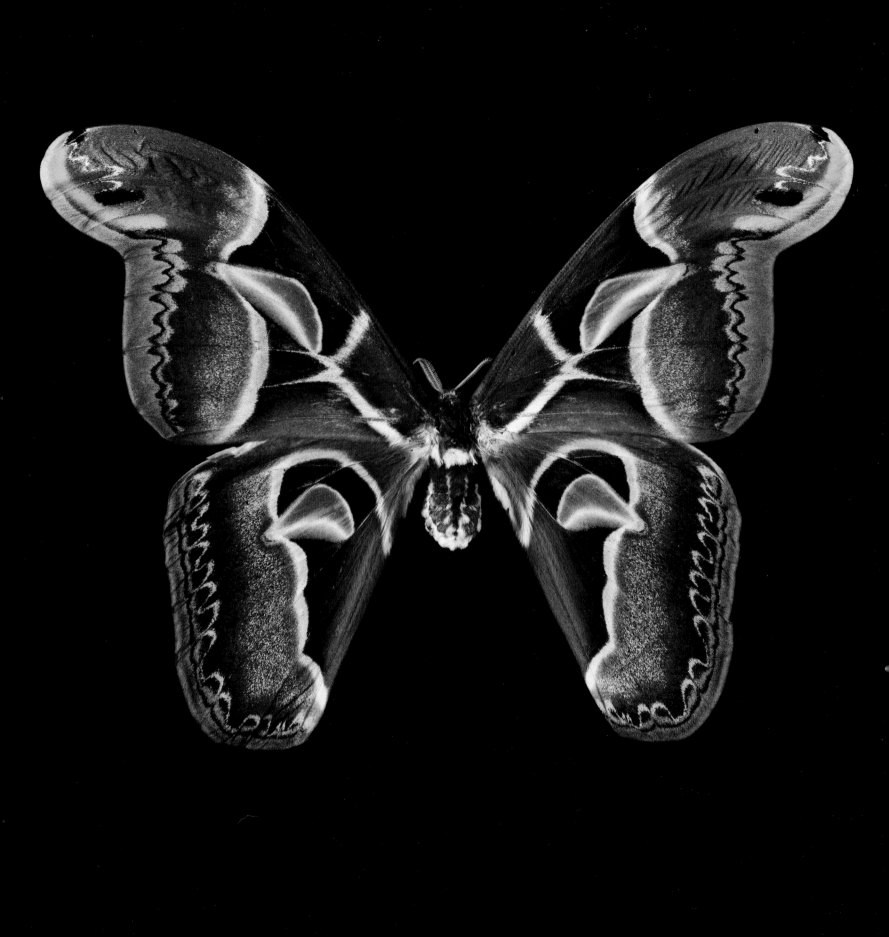

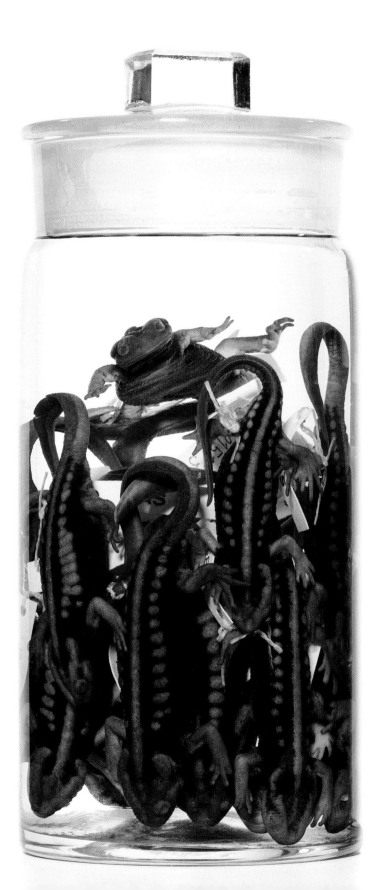

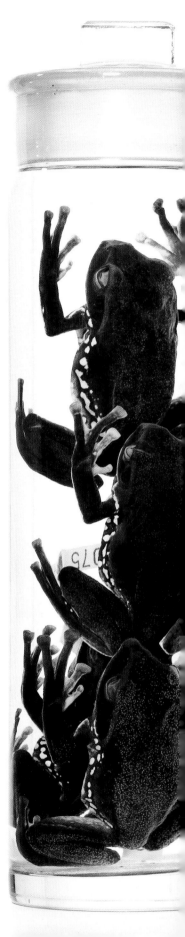

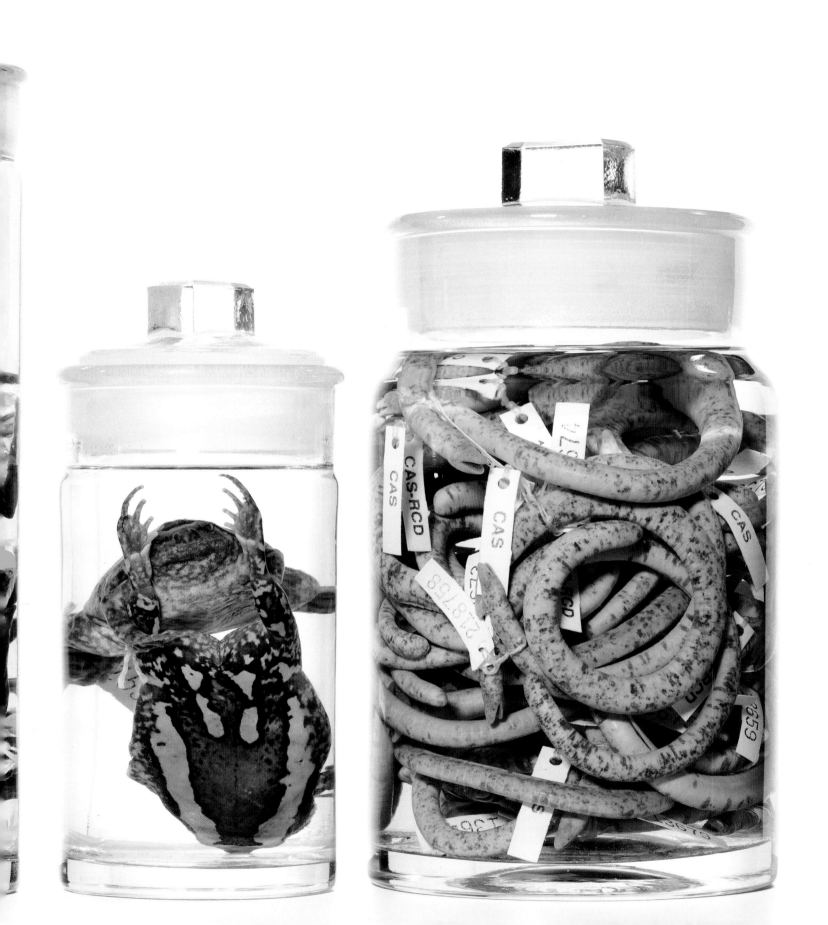

HOW DOES LIFE WORK?

Most of us use the term "evolution" as synonymous with change, but the word is from the Latin *evolvere*, meaning "to unfold." Evolution is a series of relationships connecting all life on Earth at this moment and back through time, both a history and a picture of what comprises life now. We establish these relationships through various means, but tangibly through the evidence of specimens. An evolutionary biologist first determines exactly what a specimen is and where it fits within densely articulated classification systems. Most disciplines, like botany, use something called a dichotomous key to begin placing a specimen within a genus and to identify it further as a particular species.

Dichotomous means "divided into two," and thus the key lays out a set of either/or questions that quickly sort the features of the specimen: Is a leaf evergreen or deciduous; does it have six lobes or four? These either/or questions get specific down to the chemical compounds found in the plant's metabolic pathways, down to the molecular structure of its DNA. Every answer helps determine where the specimen belongs, what it is related to, and its age. Sometimes, however, the scientist cannot fit all the details of a specimen into a previous picture and experiences the thrill of discovering something new. Once the identity of a specimen has been firmly determined, it takes its place in the vast jigsaw puzzle science is constructing to depict this unfolding of life on Earth.

The basic framework for understanding evolution is the fact that all living things have parents (mostly two, but not always). Darwin's terminology "descent with modification" refers to the fact that new variations in individuals result from transmission of traits, half contributed by a mother and half by a father. He was unaware of Gregor Mendel's work on inheritance of traits in pea plants, although the two men lived at the same time. Mendel identified how hereditary factors sort out and come back together; called genetics, this science is integral to the pattern Darwin identified.

Later work in the field showed that change occurs not only from new combinations of genes, but through a process known as genetic drift. Cells divide by replicating themselves, a copying process that is frequently imperfect. The copies end up being slightly different from their originals. Some scientists say the resulting mutation is caused by "mistakes" in genetic copying, but since there is no intention on the part of cells, it seems more accurate simply to say that "changes" are made during genetic copying. Change, whether effected through new combinations of genes or genetic drift, is fundamentally necessary to evolution, providing the raw materials for innovative forms. Over time, changes in a population's genetic makeup accumulate to the point that a species is effectively separate from its ancestors. One of the central goals of evolutionary biologists is to locate the point at which this divergence occurs.

Opposite: This Puma *concolor* was donated to the California Academy of Sciences by the U.S. Fish and Wildlife Service; it was likely given to this agency when it became illegal to hunt and mount endangered species. The puma is threatened by habitat loss.

Overleaf, left: Venus arose from a scallop shell, ordinarily the home of a bivalve, which propels itself away from predators by contracting its adductor muscle and clapping its two shells open and closed.

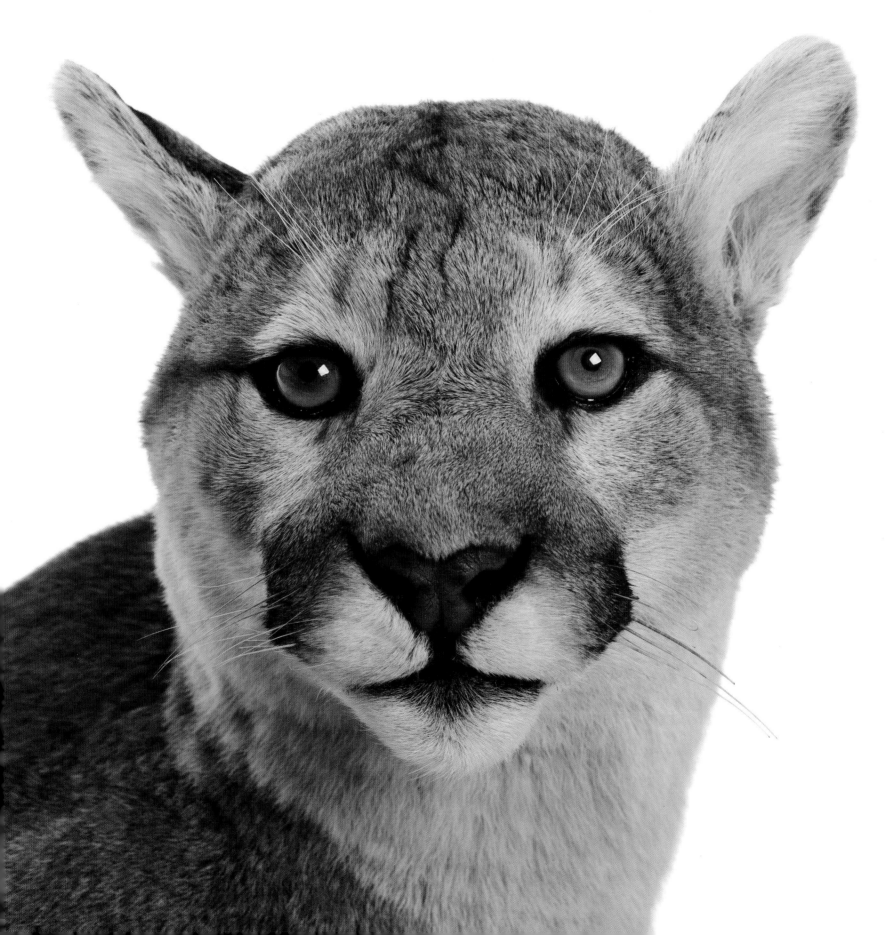

THE FAMILY TREE

Science uses the model of a branching tree to illustrate phylogenetics—*phylo* meaning "race," and *geny* meaning "generation." Phylogenetics is the vast family history of all nature, past and present. In the 1950s, German entomologist Willi Hennig developed a format, called cladistics, to place species on the tree of life, fulfilling Darwin's assertion that "all true classification is genealogical." *Clade* is from the Greek meaning "branch," and cladistics puts everyone who shares a common ancestor on a branch according to "shared derived characteristics." In other words, Hennig defined relationships by looking back to a common past.

On the tree of life, one branch starts from the place where four limbs evolved, and branching from there are amphibians, turtles, and mammals. Cladograms are diagrams showing these relationships; the making and revising of them are the day-to-day work of taxonomy. Cladograms connect species through shared derived characteristics, and then point to divergences. For example, humans and chimpanzees share a common ancestor, but we did not evolve from chimps and chimps did not evolve from us. We share an ancestor that was neither human nor chimp. We branched from the same point, and have evolved traits unique to our own lineage. Cladograms are like pieces of a jigsaw puzzle with a temporal dimension; in showing when one species branched into others they shed light on geology, on the history of the Earth's climate, and on the instigations of life itself. And parsing out historical relationships among species is often detective work.

This book offers multiple pathways into understanding and appreciating evolution. The main body of the text begins with Darwin and his famous trip to the Galápagos; while these islands off the coast of Ecuador immediately engaged his curiosity, it took years for Darwin to formulate his ideas about evolution, which he based largely on what he saw there. Darwin sent and brought back specimens from the Galápagos to England, where generations of scientists have been able to study them, ever refining what we know about how life-forms evolve. The Galápagos specimens on these pages were collected on a 1905–06 expedition sent by the California Academy of Sciences; this collection of the island's flora and fauna remains the world's most comprehensive. From there, the book discusses the fundamental processes of evolution, concepts such as natural selection, adaptation, and sexual selection, all ideas first formulated by Darwin and since vastly elaborated.

The third section of the text considers biogeography, the overall context in which any and all organisms function; biogeography is concerned with geologic and time dimensions, as well as the influence of conditions like soil and climate. Finally, the book reviews both the molecular work that, over the past half century, has so deepened our ability to examine patterns and make sense of them, and science's most recent mind-boggling revelations into evolutionary development—how an organism actually develops from an embryo. Work in this field shows that, for all the "endless forms most beautiful," as Darwin famously described the physical world, every organism from bacterium to *Homo sapiens* develops along congruent lines and is ultimately connected back to a common ancestor.

Alongside the text is an array of specimens from the California Academy of Sciences, photographed by Susan Middleton. These photographs show the intrinsic beauty and individuality of the specimens; each contains a dense reality and a potential for being understood by scientists and observers well past our own time. As physical objects, specimens can bridge the distance between art and science, beguiling us in wonderment at their specificities, oddities, and beauties. In taking its place on the tree of life, each specimen could tell an entire evolutionary story in and of itself, a small part of which is told in the captions accompanying the photographs. In producing this book we hope to help people grasp evolution as a comprehensive, yet in fact simple framework for understanding life on Earth. We hope that by revealing the beauties and complexities of individual specimens, we can help create a bridge of wonder to, and appreciation for, the components of our wondrous Earth.

IDENTIFIED AT THE
WHITMAN COLLEGE HERBARIUM
WALLA WALLA, WASHINGTON

Opuntia echios Howell
var. echios
BY E.F. Anderson DATE 5/21/68

Opuntia Echios typica
Howell.

DETERMINED BY John Thomas Howell, 1/10/33

3015.

CALIFORNIA ACADEMY OF SCIENCES

EXPEDITION TO THE GALAPAGOS ISLANDS 1905-1906
Seymour BARRINGTON ISLAND

Opuntia sp.

— south
abundant, forming low tree
like bushes 5-6 ft. high.

COLL. ALBAN STEWART Nov. 21

DARWIN AND THE GALÁPAGOS

Darwin's thought process was as slow as the tortoises that so influenced it, and as in the Aesop fable featuring the plodding beast, just as successful. Darwin did not publish his most famous work until he was fifty; he had ruminated upon and developed his ideas for more than a quarter of a century. A poster child for underachieving students everywhere (or at least for their parents, who are the ones holding out hope), Darwin was an unfocused youth prodded down various paths by his father. Historians find hints of his future direction in some of Darwin's early experiences; one of these is a taxidermy lesson he undertook while studying medicine at the University of Edinburgh. Reportedly revolted by the surgery he was supposed to perform, he quit; but the taxidermy, taught by a freed black slave who regaled Darwin with travel tales from the South American rain forest, beguiled him.

Darwin's father nudged him onto the professional path of a clergyman, which both perhaps saw as conducive to his love of the outdoors and his predilection for studying beetles—many gentlemen naturalists of the day were also men of the cloth. In 1831, when he was twenty-two, just before he was due to take his orders, Darwin instead took the opportunity to travel as gentleman's companion to Captain Robert FitzRoy, who was shortly to lead an expedition charting the coastline of South America (FitzRoy's eventual maps are highly accurate, and were used until World War II). The voyage was projected to last two years—it returned five years later. It was on this trip that Darwin famously visited the Galápagos Islands off the coast of Ecuador, a volcanic archipelago with a most intriguing population of flora and fauna. While he was intellectually curious and an inveterate observer all his life, virtually all of Darwin's paradigm-shifting thought can be traced to observations made on this trip and to subsequent reflection on the specimens he brought back. Thus did a fairly substantial "step out" by a waffling young man become the cornerstone of, arguably, the greatest scientific theory of all time.

THE MYSTERY OF MYSTERIES

Darwin sent back specimens and descriptions from the Galápagos to scholars and scientists in London, who were also intrigued with what he found there, and they accepted him into their company as an established naturalist upon his return. Even before *On the Origin of Species*, he published papers pondering the provenance of these organisms and helped to build interest in the Galápagos. Prominent natural history museums and private collectors began more routinely to go to the islands to see, and collect, for themselves.

For years, Darwin and a coterie of friends and colleagues mulled over what they called the "mystery of mysteries," the origin of species. At the center of this question is the key to life on Earth and what makes it work. The tortoises, lizards, birds, fishes, and plants brought back by Darwin were different from those found anywhere else, yet distinctly related to South American life-forms. How could they be both different and the same?

Science up until Darwin sought to understand the natural world within an original order of creation made by a Creator—a unifying and divine principle to explain and synthesize the multiplicity of nature. Scholastic philosophy organized life into a hierarchy of groups within groups. In the seventeenth century, Carl Linnaeus established a binomial method for naming and classifying plants that was extended to animals, and by so doing he laid the groundwork for taxonomical collection. His nomenclature is used to this day to place each species on its branch of the tree of life, but Linnaeus also believed each species could be traced to an original in Eden. Baron Georges Cuvier, the preeminent naturalist whose opinions dominated the scientific establishment just prior to Darwin's time, posited successive acts of creation and extinction, determined by the hand of God. Charles Lyell, whose *Principles of Geology* profoundly influenced Darwin by furthering the evidence that the Earth is millions, not thousands, of years old, stuck to an idea of successive acts of creation. Even Alfred Russel Wallace, whose formulation of natural selection closely paralleled Darwin's and whose work instigated Darwin's publication of *On the Origin of Species*, kept to a Victorian brand of spiritualism through his entire life.

Darwin's idea that species essentially develop themselves via a selection process over many, many years, while not removing God from the picture, put such an entity far offstage. The untimely deaths of several of his children thoroughly disillusioned Darwin, though he had never been quite devout; even so he was not eager to displace God from nature. He did exhaustive research on a wide variety of animals, recording details on generations of dog, cat, pigeon, and rabbit breeding, among others, and closely observed variations in plants. Synthesizing a vast array of data about changes in form over time, he came to the unavoidable conclusion that the creation of new species occurred in the context of ecology and reproduction—that evolution is a law-like and regular, not a supernatural or unusual, event.

THE ENCANTADAS

The first recorded observation of the Galápagos goes back to 1535, when ocean currents diverted the bishop of Panama and his ship there. The bishop's account to the king of Spain included descriptions of the island's tortoises, iguanas, and strangely tame birds. The first scientific mission, in 1790, was sent by the king of Spain, and in 1793 an English expedition went to see about whaling there. For the next several centuries, whalers, fur sealers, and pirates made frequent stops in the islands, mostly to stock up on tortoises, not for any intrinsic interest other than their incredibly resilient flesh. (Able to metabolize fat stored in their tissues, which produces water, tortoises can live up to a year without drinking or eating. Tortoises were stored live in the holds of ships as a ready source of fresh food; because of this, the tortoise population was vastly reduced and in danger of extinction before the end of the nineteenth century.)

Darwin had undoubtedly read these accounts, as well as those of other explorers, but it is not certain whether he had read a young Herman Melville on the subject. Melville had a decidedly dark take on these "enchanted islands"—his sketches, some of which were published in *Putnam's Monthly Magazine of American Literature, Science and Art* in 1854, were titled "The Encantadas," after the islands' ancient Spanish name. "Take five-and-twenty heaps of cinders dumped here and there in an outsize city lot, imagine some of them magnified into mountains, and the vacant lot the sea; and you will have a fit idea of the general aspect of the Encantadas." Further, he described the "special curse" of the Galápagos, owing to the fact that to the place "change never comes." Melville correctly observed that lying near the equator, the Galápagos did not undergo seasons the way we usually recognize them (there are rainy intervals), and he interpreted this sense of timelessness as akin to a season in hell. In the iguanas he encountered "something strangely self-condemned" in appearance. On the contrary—alone among iguanas anywhere on the Earth, these adapted to their watery surroundings; Darwin noticed them eating algae and seaweed and swimming with the use of their long, flat tails.

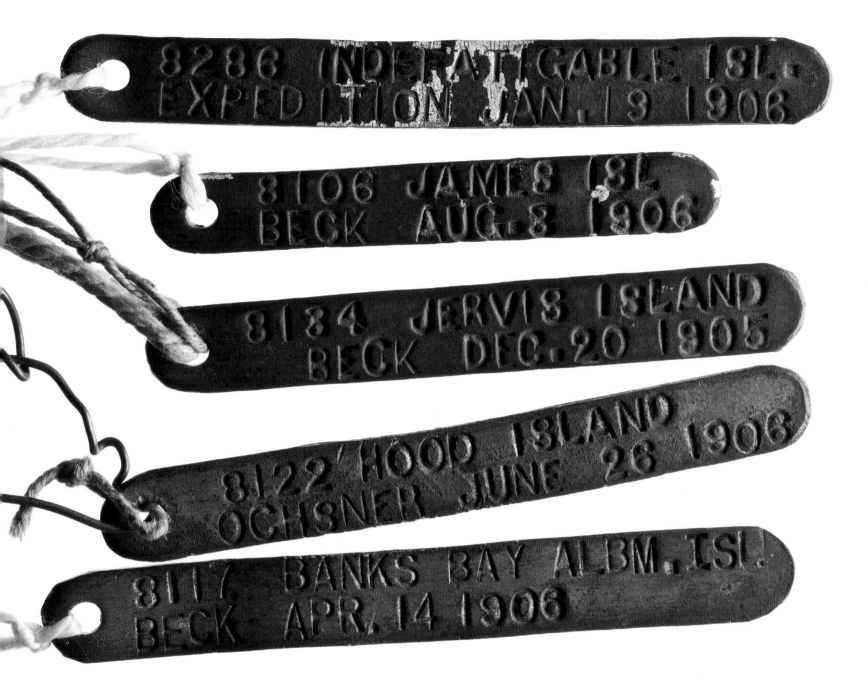

8286 INDEFATIGABLE ISL.
EXPEDITION JAN. 19 1906

8106 JAMES ISL.
BECK AUG. 8 1906

8134 JERVIS ISLAND
BECK DEC. 20 1905

8122 HOOD ISLAND
OCHSNER JUNE 26 1906

8117 BANKS BAY ALBM. ISL.
BECK APR. 14 1906

Previous spread, left: This candelabra cactus, *Jasminocereus*, is related to *Armatocereus* in South America; originally, seeds from the plant were likely deposited on the Galápagos in bird droppings and successfully colonized. The labels on this specimen show that it was originally collected by Alban Stewart. Named in 1935 after J. T. Howell, the botanist who described it, it was then likely requested for study in Walla Walla, Washington, where its provenance was confirmed by another botanist, E. F. Anderson.

Above: Identification tags from the California Academy's 1905–06 Galápagos expedition give each tortoise specimen a number, tell which island it came from, who collected it, and when.

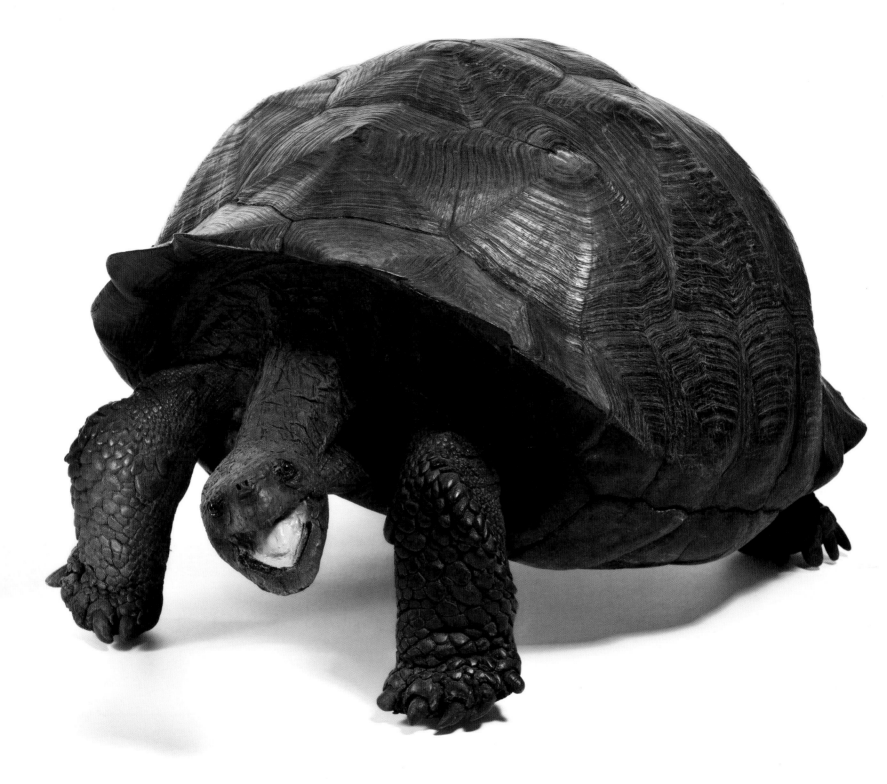

Pages 24–29: In these tortoises you can see the same evidence of evolution Darwin did: different physical shapes that have evolved in response to different environments. The smaller, saddleback tortoises are accustomed to relatively abundant vegetation that is easily accessed. The larger, dome-shaped tortoises have a long neck with the carapace pulled back like a collar, and are adapted to reaching high for their supper.

DE NOVO

Melville described the Galápagos as a dead end, as if time had come to the finish line there. Darwin saw the islands from the opposite perspective; he saw the Galápagos as a land formation in a stage of birth, its flora and fauna in a state of change. Scientists still love to study islands, partly because their physical isolation intensifies the relationships among various organisms, and their restricted area makes it relatively easy to observe their interactions—islands are isolated cases that are paradigms of the dynamics that shape the entire Earth. Charles Lyell's work showed that rather than having been created in a single swoop, land formations had been made in concert with the oceans over immense periods of time. In the geologic term for it, the volcanic islands were newly emerged. Darwin could see which ones were older and which younger by the amount of vegetation on each: The newer islands were big piles of black lava worthy of Melville's mordant wonder; on the older ones, erosion had created an environment for a relative abundance of vegetation to grow and support other life.

Volcanic islands have never had any contact with a continental landmass (they are called oceanic), which means any life on them originally came from somewhere else. Most species disperse by flying (or are blown by the wind), swimming, or hitching a ride. Not only must an organism survive a hazardous journey to a new place, it also needs the company of its own kind for reproduction to establish a viable population. The waif Galápagos flora and fauna have relatives found on nearby continents, but the islands definitely have a lopsided profile. There are reptiles but, originally, no amphibians, many birds but few mammals, and no plant groups with large flowers or heavy seeds. How, then, did these populations first come to the islands?

Penguins, sea turtles, and sea lions are all good swimmers, and strong currents probably helped them arrive in the Galápagos. Giant tortoises can float for long periods of time. Rafts of vegetation are routinely washed down raging rivers and out to sea, carrying reptiles, insects, and even mammals to new locations. While much of what is on the Galápagos is now known to have originated in South America, DNA analysis suggests more diverse origins for some species: The flamingos and pintail ducks trace their heritage to the Caribbean; penguins and fur sea lions hark back to the sub-Antarctic; and the endemic Galápagos sea lion comes originally from Baja, California. It is likely that newcomers came again and again to the Galápagos before any distinct populations of each were able to form—birds could fly but not live there until there was enough vegetation to provide them with food, water, and nesting materials. Once there were plants for birds and insects, then there could be iguanas and other birds to feed on them. (Plant seeds are dispersed by air and by the birds who eat them; most flowering plants need to be pollinated by a particular insect or bird, and it's unlikely for both the plant and its pollinator to arrive in the same place at the same time.) The special case of island endemics depends on a distance both close enough to a mainland that some invaders actually make it there, but far enough away that subsequent invasions don't flood the gene pool. Islands like the Catalinas, off the coast of California, for example, do not experience the same kind of genetic isolation.

While Darwin was visiting the Galápagos, the locals claimed they could tell which island a tortoise came from just by looking at it, and he was intrigued by the morphological differences among them. Tortoises from different islands are of various sizes and differ mostly in the shape of their carapace, or shell. And the cacti that grow on the islands and nourish the tortoises have in turn evolved partly in response to their predator. On the islands where tortoises merely browse from time to time, the cacti spread low, and their spines, which are modified leaves, are soft. To defend themselves against being eaten, those cohabiting day in and day out with tortoises are treelike, with elevated pads and stiff spines. It is geographic isolation, perfectly exemplified among the island populations, that drives speciation, the process by which new species arise. "Species" is from Latin, meaning "kind" or "sort." Although it is said that given any ten scientists you will get ten different definitions of what exactly constitutes a species, one unequivocal dividing line between species is the inability to

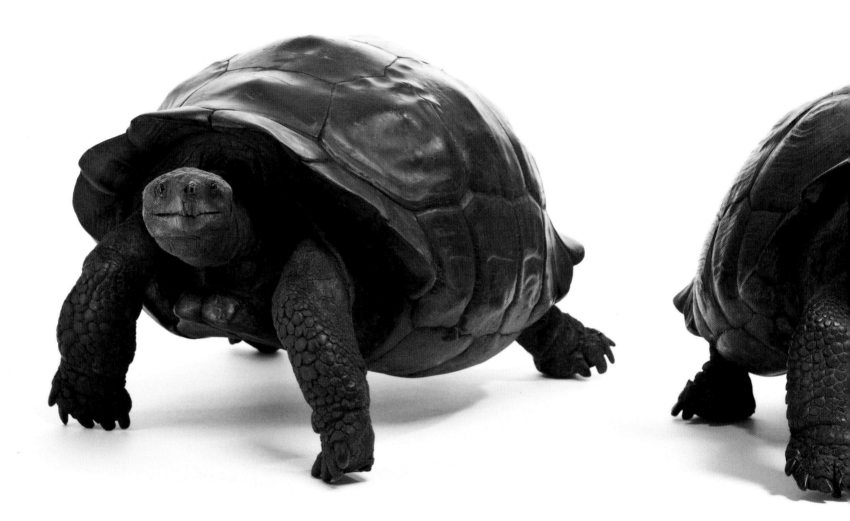

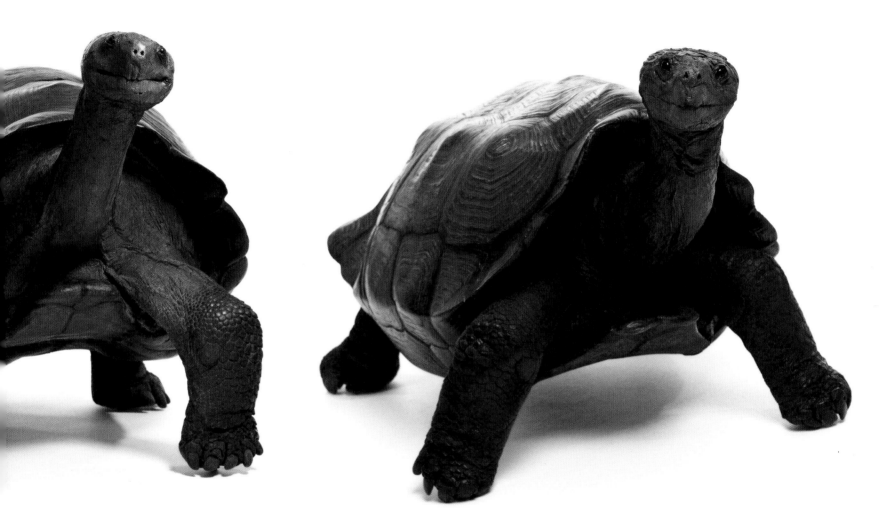

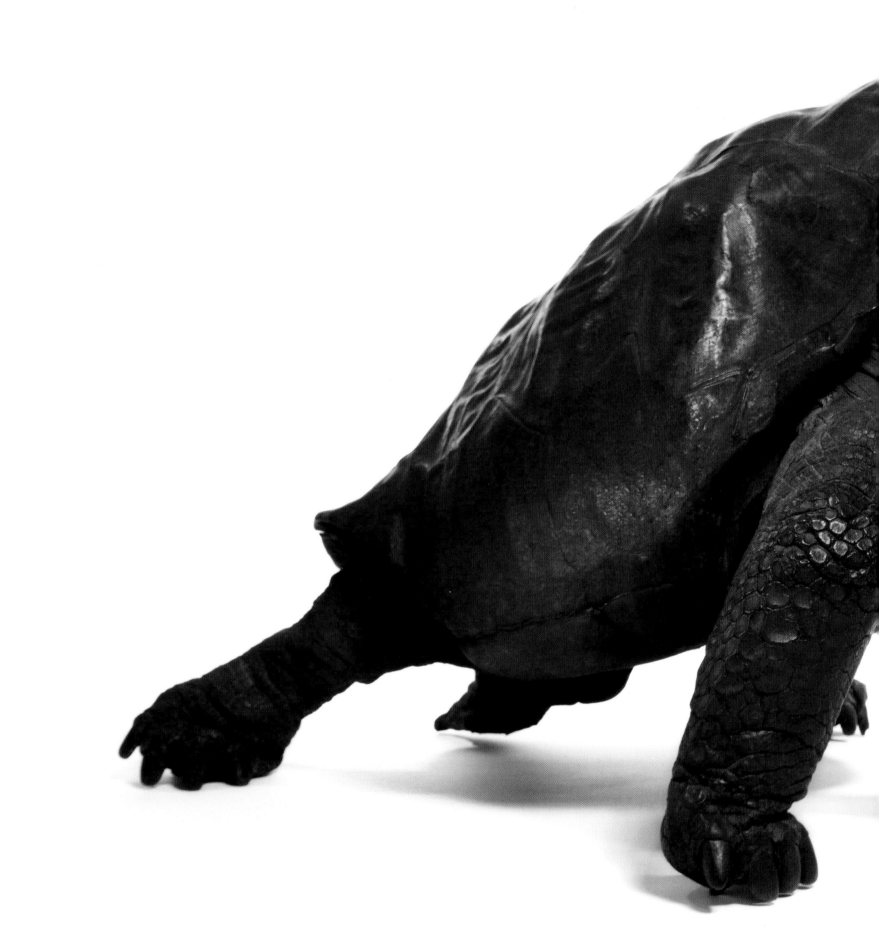

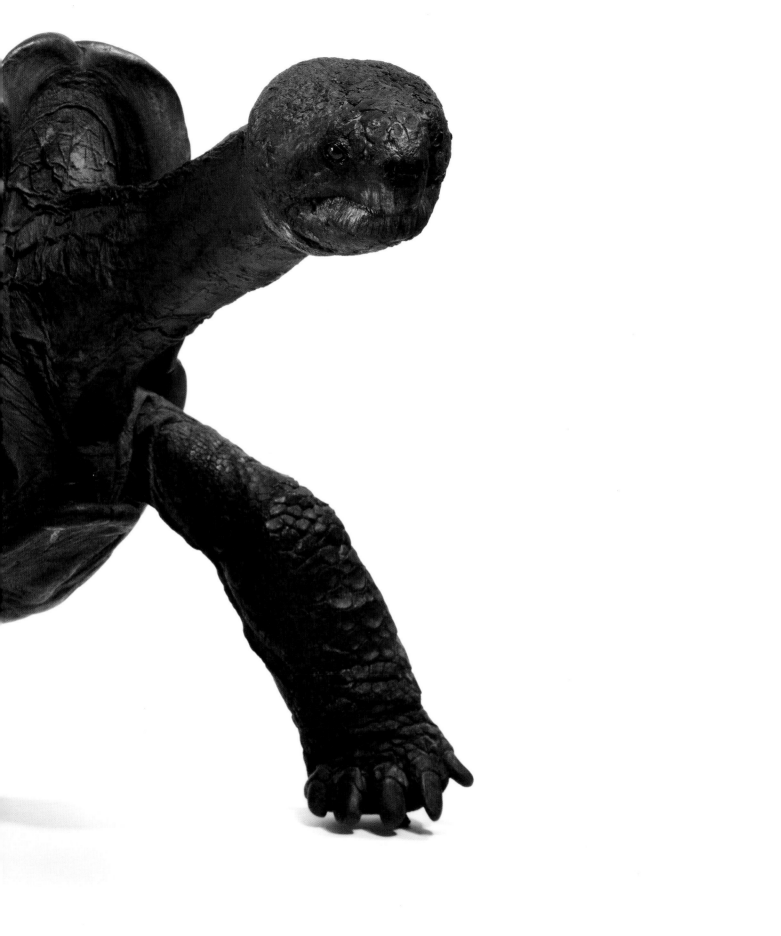

reproduce successfully together—a horse and a donkey may produce a mule, but it is sterile. Natural selection produces novel species using the same mechanism of genetic inheritance, whether it is working in mice or men. But species diverge at vastly different rates and to different extents. Today the Galápagos tortoises are recognized as the same species, *Geochelone elephantopus*, but divided into fourteen subspecies differing by shape, color, thickness of shell, neck and leg length, and overall size. Of these fourteen subspecies, nine are endemic to particular islands; three of these endemic subspecies are extinct, and Pinta Island has a single extant representative, Lonesome George.

In recent years, scientists have tried to facilitate progeny for Lonesome George and thus save his lineage. Their quest has been to find him a suitable mate, since individual species only breed among themselves. Using DNA samplings of tortoise specimens from the California Academy of Sciences' collections, another subspecies with a long-ago connection to George's was uncovered, and at last watch, George had indeed successfully mated with two tortoises identified as having Pinta ancestry.

Certainly, no one bringing back tortoises from the California Academy of Sciences' 1905–06 expedition could have imagined that one day their bounty would help save a lineage of tortoises from extinction. Lonesome George is a fine example of why it is so important to safeguard specimens, the representative samplings of life in a particular time and place, for future use. Right now, finches from the 1905–06 expedition are being studied for clues into better understanding the avian flu: Bird feathers, like human hair, carry traces of toxins that can be present in the body. Putting together a disease history of birds can help in understanding how diseases develop and travel. And, as climate change encroaches, there may come a day when we will need the specimens to tell us what life was like under "normal" weather conditions. Darwin could not have imagined the problems we confront today or the tools we have developed to address them. Neither can we know what the future will bring. The specimens, however, will always have their stories to tell.

Opposite: This finch nest was collected in the California Academy of Sciences' 1905–06 Galápagos expedition; more than one hundred years old, its pristine condition is testament to the intense care that went into building it. Small birds like finches lay fragile eggs, hatching into chicks that are unable to control their body heat; the nest acts not only as a home and a protection from predators, but as an incubator. The parent birds rely on their own body heat rather than the sun's to gestate their progeny.

Overleaf: Among the most obsessively studied of all birds, the thirteen Galápagos finches illustrate adaptive radiation par excellence. The different sizes and shapes of their beaks have allowed them to make a living side by side, utilizing different strategies for obtaining different food sources. The small, medium, and large ground finches on the upper left have beaks adapted to crush seeds; the sharp-beaked ground finch on the bottom left is so-called for its ability to extract blood from sea birds; the large and common cactus finches next to it have probing beaks for penetrating cacti. On the right top and bottom rows, the woodpecker, small, medium, and large tree finches and the mangrove finch are all insect-eaters. Finally, the vegetarian finch's beak is shaped like a parrot's, giving it a good hook into the fruit upon which it subsists.

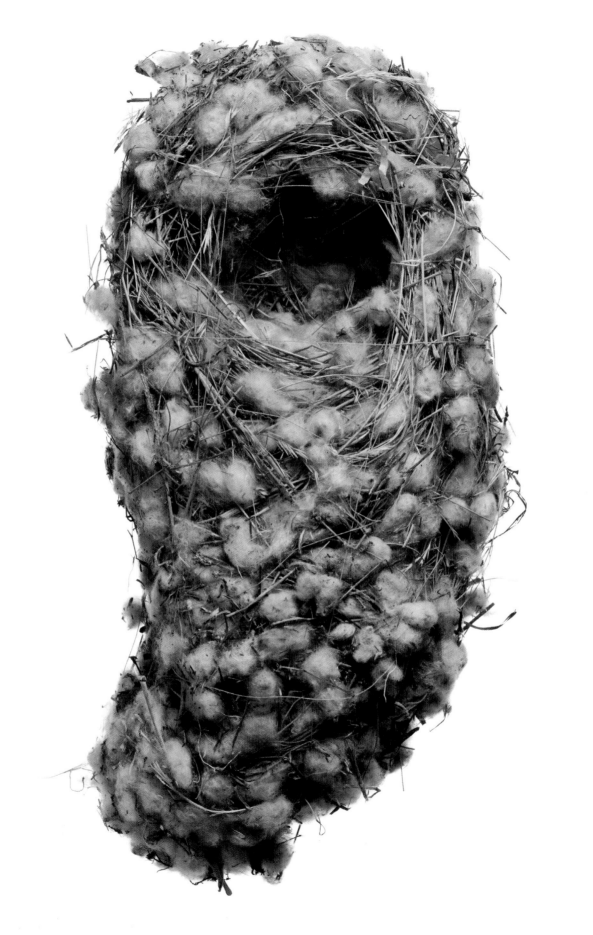

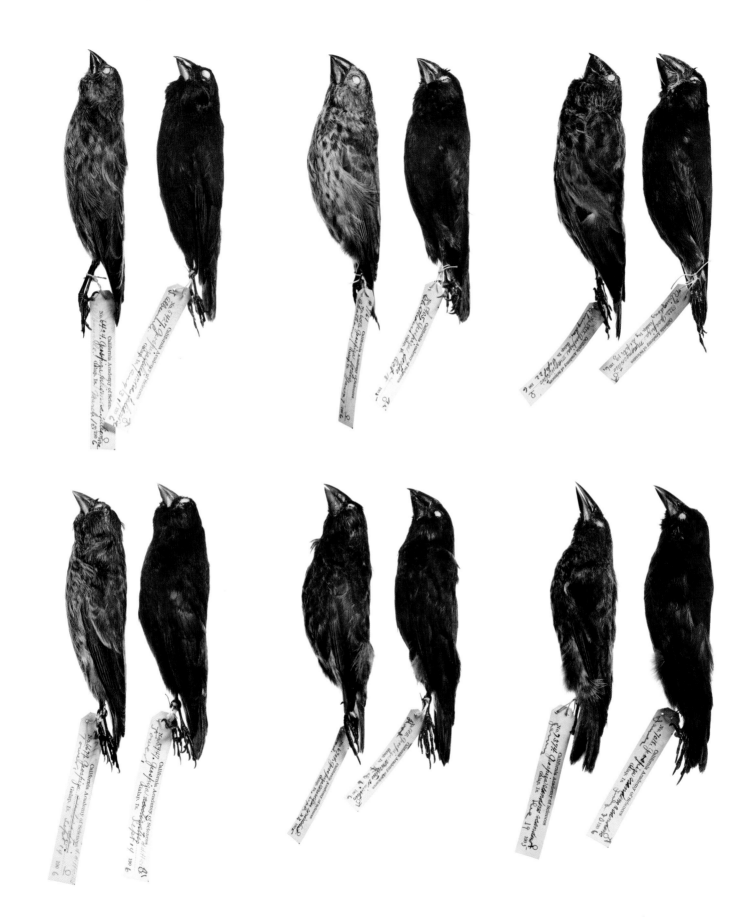

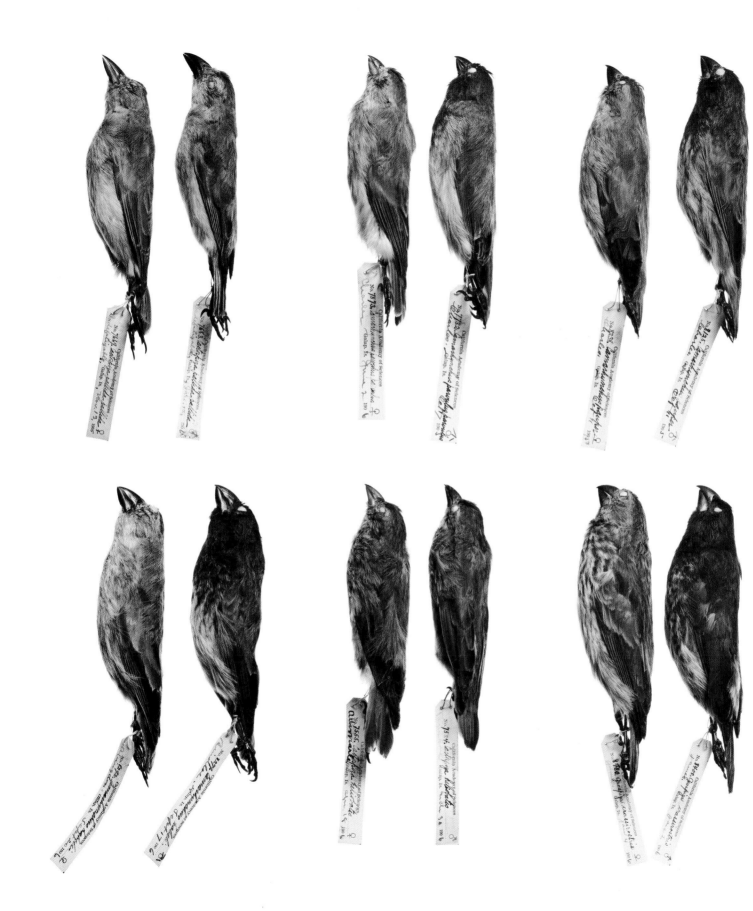

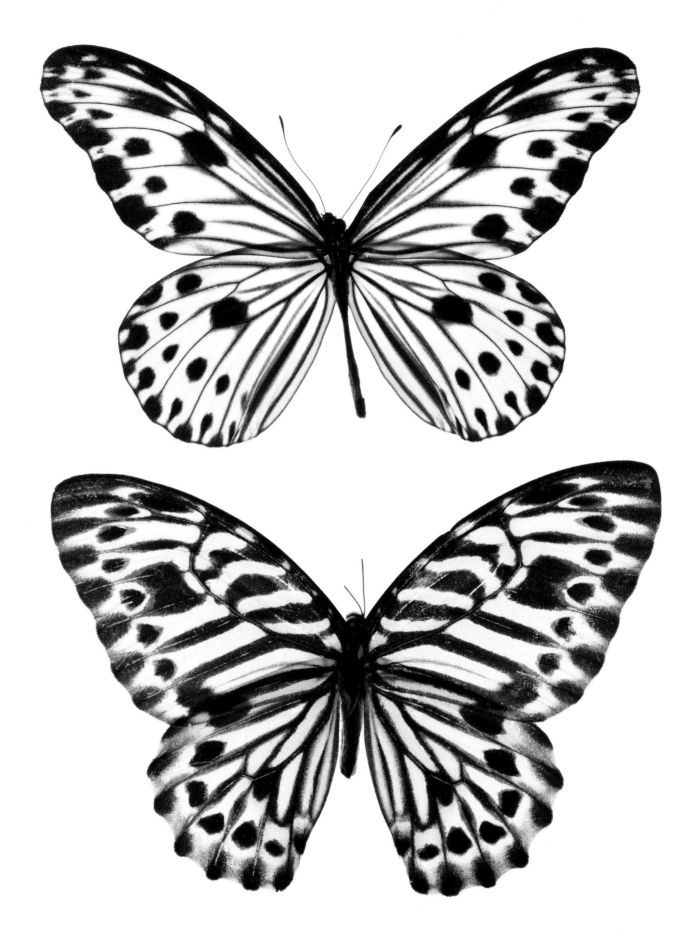

PROCESSES OF EVOLUTION

NATURAL SELECTION

Science had understood that life-forms change over time before Darwin published *On the Origin of Species*; it was his explanation of how this change occurs that challenged conventional wisdom.

In 1858, together with Alfred Russel Wallace, Darwin presented the theory of evolution by natural selection to the Linnean Society. They argued, based on the fact that there are more individuals of any species born than can normally live to maturity and reproduce, that there exists a struggle for survival among species; that within a population there are individual variations in features, some of which will help or hinder an individual's ability to survive and reproduce; and that variations in individuals are inherited, so the characteristics of successful parents will be passed on with more frequency. This chain of genealogical events serves to increase the survival ability of the species, at least to a point. Neither Darwin nor Wallace offered any proof for the theory of natural selection. *On the Origin of Species* doesn't demonstrate a single case of natural selection leading to new species; it just argues that logically this must be so. But the concept was so powerful that generation upon generation of scientists have tested and questioned its veracity. One of the most robust documentations of natural selection in action was recorded in the 1970s, occurring among the famous finches that still populate the Galápagos to this day.

Opposite: Mimicry is a common evasion strategy among insects, fish, and other animals, and it can work several ways. Shown here are two butterflies from Malaysia. The top one, from the Danaidae family, is toxic and doesn't taste good to predators; the bottom one, from the Papilionidae family, has copied the drop-dead look to repel aggression by association.

Overleaf: *Kallima inachus* has the best of both worlds: the splendor of color (top left) and the cover of camouflage (bottom left). When closed, its wings mimic the appearance of a leaf (right). Butterfly and moth wings are covered entirely with scales, which evolved from the sensory bristles still carried by flies. They have lost "innervation," or the ability to register sensation, but they have compensated with looks. Each scale has its own color.

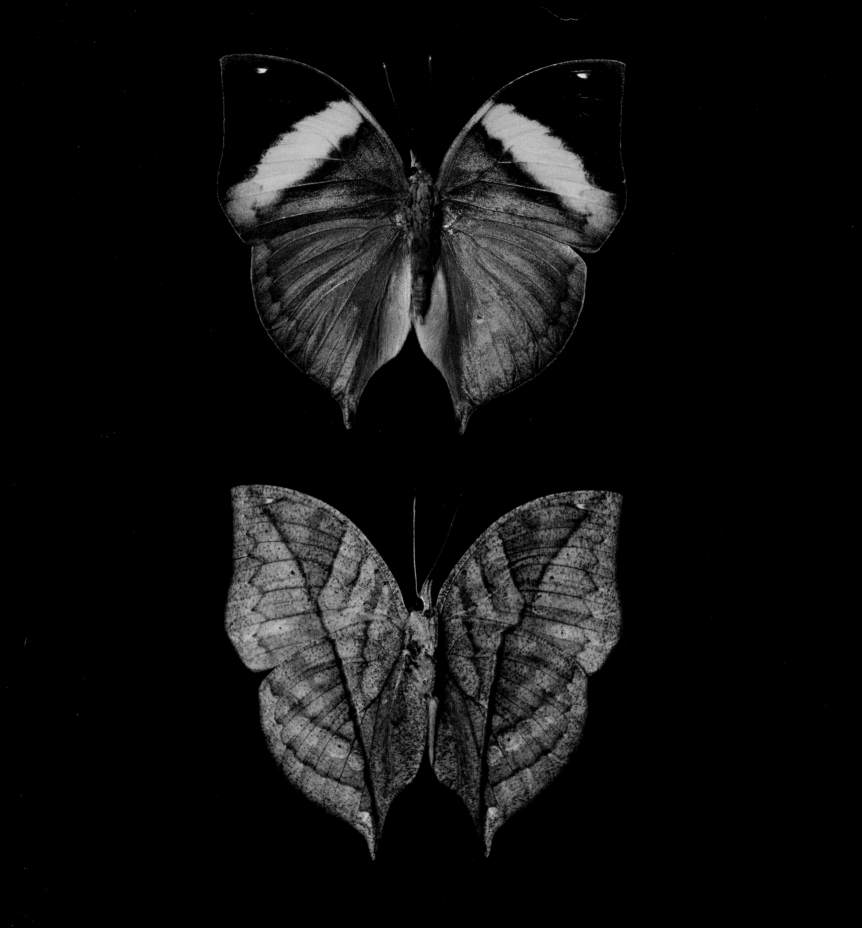

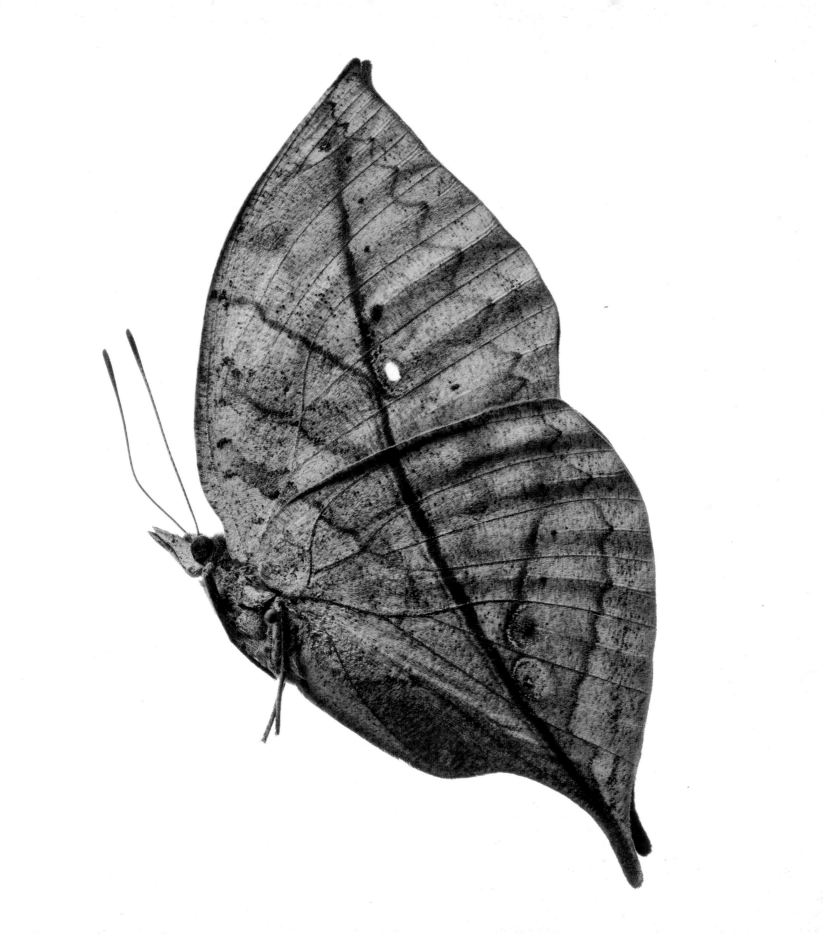

MAY THE BEST BEAK WIN

While he noticed the differences among the Galápagos tortoises right away, Darwin was not as percipient about the finches he saw there. He shot thirty-one birds, eventually to be identified as representing nine of the islands' thirteen species. He stored them together, not noting which came from which island. Since distinctions of location are critical to parsing out selection processes, Darwin later regretted this omission. The wide diversity of the finches effectively disguised their speciation status, and Darwin took their plentiful differences for the kind of variety you find in leaves on a tree. At the time, he could not know that the finches would prove so critical, two hundred years later, to demonstrating his theory of how evolution works through natural selection.

When Darwin returned to England from his trip on the HMS *Beagle* in 1836, he deposited all the birds he had collected with the Zoological Society of London. The cache was very exciting indeed to the specialists there, and Darwin's friend John Gould soon noticed that the finches were especially distinct. Based upon Gould's questions, Darwin went back to FitzRoy's log and tried to determine from which island, in fact, each had come—but to no avail.

The thread of scientific inquiry thereafter is highly disjointed; biologists went on to study Darwin's finches for more than 150 years, picking up one of Darwin's topics and investigating it ever more deeply. Forty years after Darwin donated the finches, an ornithologist named Osbert Salvin methodically measured the finches' lengths, wingspans, weights, and especially their beaks. One hundred years after Darwin's trip, another ornithologist, Percy R. Lowe, christened the Galápagos' famous avians "Darwin's finches" and postulated that their variety showed no evidence of natural selection. In the mid-twentieth century, another British ornithologist, David Lack, published *Darwin's Finches*, based largely on work with the specimens at the California Academy of Sciences. In fact there are two versions of the book; Lack at first considered the different beaks as "isolating" features, but soon after publication he reconsidered and then produced the work

that another generation would use to help demonstrate natural selection visibly and tangibly. For the past thirty years and more, scientists have yearly visited the finches on one small Galápagos island, observing them closely and, with their students, measuring, weighing, and studying every conceivable feature of the finch population. They have gotten to know generations intimately, even naming some of the finches and watching them become grandparents.

Darwin felt that evolution could be observed only over a very long interval, after "the hand of time has marked the lapse of ages." This was his fundamental difference from Jean-Baptiste Lamarck, who had articulated a coherent picture of evolution but posited "acquired characters" as the mechanism of morphological change. Thus Lamarck would say the giraffe acquired its long neck because successive generations had stretched to reach high treetops, incrementally passing the trait on to their progeny and producing measurable changes in a relatively short period of time.

Darwin's contention was that a physical change made in one generation wouldn't establish itself in the population so quickly. Darwin didn't know about genetics, but he correctly intuited a mechanism whereby traits, formed from the character contributions of each parent, were actually selected for among new organisms.

Lamarck was wrong and Darwin was right, but recent work on the Galápagos finches has vindicated at least part of Lamarck's thinking: Natural selection can indeed work fast—in a single generation. In many a textbook you will see proud portraits of the thirteen species of finch, highlighting their distinctive beaks. One scientist charted these beaks, showing them as analogous to pliers: Those with diagonal pliers and those with chain-nose pliers rely more on leverage; others have parrot-head pliers, curved needle-nose pliers, and straight needle-nose pliers, all adapted to different seed-cracking challenges. Birds spend most of their time eating, and the beak is their tool, their lifeline. Birds use their beaks to interact with their world much the way we use our hands. The Galápagos finches have all sorts of strategies for getting along in their world: One famous species, the vampire finch, pecks at the blue-footed booby until it draws blood from its wings or tail, which it then drinks (a more cooperative finch helps rid tortoises of parasites on the relatively sensitive skin around its neck).

Specimen tags (reading on the two bird labels):

No. 495a Certhidea
bifasciata ♀
Barrington, Galap. Is.
California Academy of Sciences
Oct 20
1905

No. 4767. Certhidea
bifasciata
Barrington, Galap. Is.
California Academy of Sciences
Oct 20
1905

Left: Darwin did not recognize the significance of the various Galápagos finches at first, but his understanding grew with years of study and reflection. This warbler finch is one of thirteen species found on the islands (the others are shown on pp. 32–33).

Pages 40–45: Butterflies trick predators into thinking they are someone else; these stick and leaf insects pretend not to be there at all. Belonging to the order Phasmatidae (from the Greek *phasma*, meaning "apparition"), these bugs imitate the structure of thorns, twigs, and leaves. Taking the charade further, they maintain near perfect stillness or gently sway as though rustling in a breeze; when disturbed, they go cataleptic and fall to the ground as if dropped.

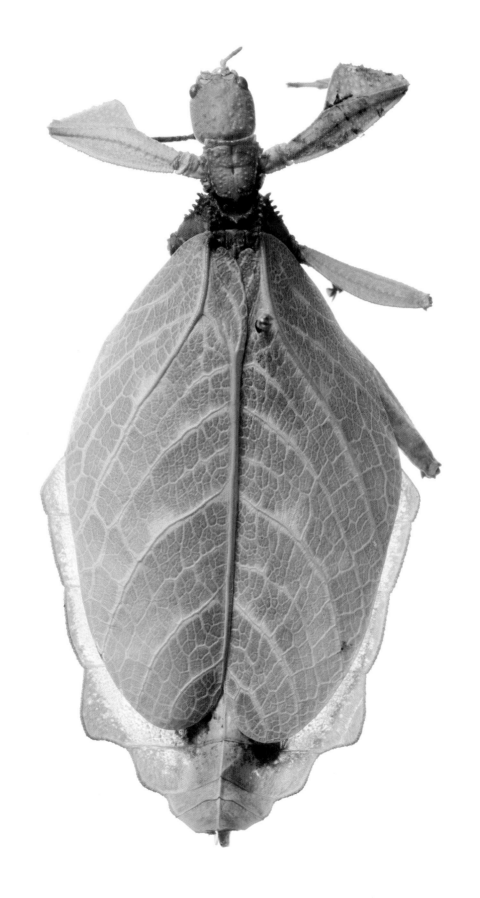

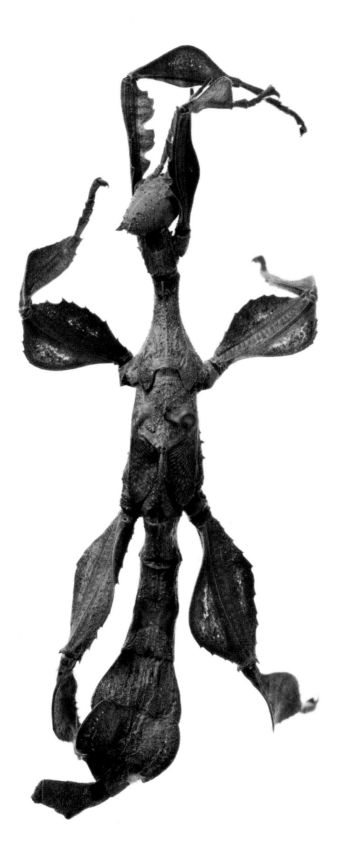

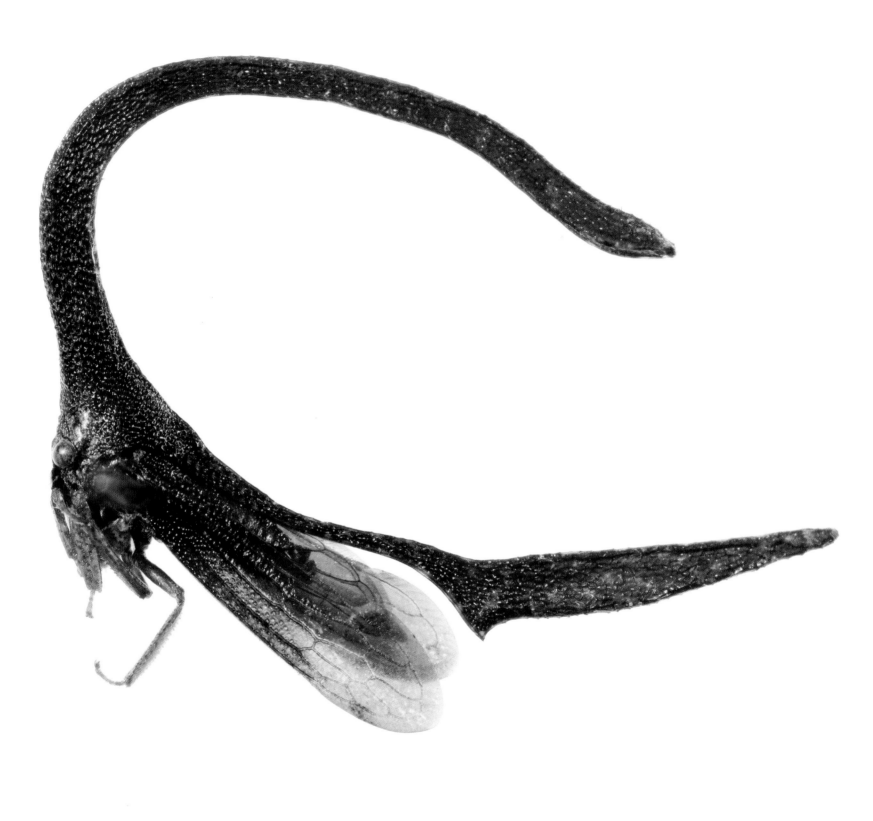

In 1977, one scientist, Peter Boag, working on the island of Daphne Major in the Galápagos, decided to measure parent bill size relative to the bill size of their offspring; he wanted to study heredity. Already-collected data showed Boag that beak size is highly heritable, meaning that if your daddy's beak was big and your mommy's beak was big, yours was going to be big, too. However, evidence of the size alone did not prove that genetics had anything to do with it. It was possible that a big-beaked parent was able to provide more food for its offspring, resulting in bigger, better-fed progeny. Big-beaked babies might have nothing to do with the bird's gene pool.

Boag set out to do an egg-switching test, to take some eggs from a pair of big finches and put them in the nest of a pair of small ones, and watch how they grew up. But Boag never got to do his egg switch. A drought hit Daphne Major, and hit it hard. Birds dropped like proverbial flies, and they didn't mate. The number of finches on Daphne Major in 1976 was fourteen hundred; by December 1977 it was down to three hundred. Boag and his colleagues were depressed, feeling they were missing out entirely on their quest for heritability data. They didn't realize right away that they were being presented with quantitative evidence for selection; thinking it was something that took aeons to occur, they didn't understand that they were watching the mechanism of evolution right before their very eyes.

The birds that survived the drought were the oldest birds, with the biggest, deepest beaks. As the seeds that the starving birds depended on dwindled to nothing, the birds with the most tenacious beaks were able to crack hard seeds that had been completely ignored before the drought. Birds with smaller beaks were simply unable to deal with the seeds. Finally, rain came, and the remaining finches bred again. The drought had wiped out all but a negligible number of females; there were a hundred and fifty male survivors. And when the remaining females picked their mates, they picked the biggest of the big. The birds of the resulting new generation had beaks 4 to 5 percent deeper than the beaks of their ancestors. When they mated, the birds sealed the deal: This was natural selection in action. The birds with the biggest beaks survived, with a genetic inheritance to pass on. Thus are features selected for in a constantly shifting ecosystem, impacted by earth cycles like El Niños and ice ages.

THE MUSICAL SHUTTLE

Walt Whitman celebrated the mockingbird's song as a unifying rhythm of all life; the Hopi credited the polyglot bird, able to imitate virtually any other bird's song, with bringing language to each human tribe. It is understandable, then, that Darwin's reflections on natural selection were in fact based more on his observations of Galápagos mockingbirds than on the islands' finches. "My attention was first thoroughly aroused by comparing together the various specimens . . . of the mocking-thrush," he wrote in *The Voyage of the Beagle*, the eminently readable account of his journey with FitzRoy, published as his *Journal and Remarks* in 1839. When he disembarked on Chatham Island, now known as Isla San Cristóbal, Darwin was confronted by a *Mimus melanotis*, similar to the single species of mockingbird he had just encountered in South America. Observing three separate species on three separate islands (the fourth endemic species, on Española, was discovered many years later), he wondered if a single colonization had "branched" and added to this his idea that all mockingbirds were descended from one original ancestor. In *On the Origin of Species*, he writes: "Let us suppose the mocking-thrush of Chatham Island to be blown to Charles Island, which has its own mocking-thrush: why should it succeed in establishing itself there?" He noted that on Charles Island "more eggs are laid there than can possibly be reared," suggesting that the mockingbird's niche was already more than filled.

Darwin's musings on natural selection were jump-started when he read *An Essay on the Principle of Population* by Thomas Robert Malthus. Malthus observed that in times of plenty, populations tend to increase rapidly, outstripping the available food supply, until they crash. (Many scientists today say the human race is actually, not just potentially, in the process of extinction, based on the fact that we consume more units of energy, be it oil or calories, than we replace.) The Charles Island mockingbirds had a hold of their territory and its resources, and there was and is no reason for them to allow the Chatham Island mockingbirds to horn in on it. The subtitle of *On the Origin of Species* reads: *by Means of Natural Selection, or the Preservation of Favoured Races in*

the Struggle for Life. Key to Darwin's hypothesis is the idea that there isn't, actually, enough to go around, and any organism that can adapt a feature that will put it ahead of the competition will be selected for in future generations.

The question of why there are so many finch species, some cohabiting the same island, while competition has put an island barrier up among mockingbirds, goes to the heart of evolutionary processes, and is fodder to this day for plenty of study and discussion. Cohabiting finches have developed different ways of making a living, so that they can do it side by side. If you are a bloodsucking vampire finch, the vital fluids of the booby are your "niche," and no direct competition need be undertaken with a seed-cracking finch. "Niche" is from Middle French meaning "nest," a term resonant not only with place but habitat and the implication of belonging. An organism's niche is at once its location and its way of making a living. Herbert Spencer's term "survival of the fittest" might more aptly be interpreted as meaning not necessarily buff and lean, but as fitting best into a niche. Finches have this wondrous thing, a variable beak, and pretty quick changes to it can fit new finches into new niches. Mockingbirds don't crack seeds; they eat insects. It may be that they don't have the same intrinsic flexibility to adapt that finches have. Similar to the finches, lava lizards all over the Galápagos have also capitalized on their ability to find new opportunities in new environments. When one ancestor species diversifies to take advantage of different niches, this is called adaptive radiation.

ADAPTATION

"Adaptation" is perhaps as broad a term as evolution itself. An adaptation is simply a trait geared toward better survival in an environment. Changes in physical characteristics, like the development of wings, how an organism gets food or "makes a living," predator/prey relationships, and mating strategies—basically anything and everything an organism does to survive and reproduce—come under the rubric of adaptation.

Nature is profligate, but relies on a fairly standard set of adaptations, such as wings, coloration, limbs and limblessness, and so on. Cacti in a desert look like they are closely related, but in fact they usually represent a variety of lineages that have all adapted to the environment using similar means, developing spines and a thick cuticle. The phenomenon of similar physical features appearing among very different species, or species that have developed at different times, is called convergence. One of the critical components to identifying the progression of a lineage are so-called conserved features, like the spiral shell of the chambered nautilus and the spirula. Conserved features are so valuable they have either been retained across great time periods, or else evolved more than once, like wings. Evolutionary biologists often must decide whether similar features in different organisms indicate an actual genealogical relationship, or if they are an example of convergence.

Adaptation is all about change. Scientists look for differences in subsequent generations of related species to locate when, and perhaps why, species diverged. For example, in 2004, Neil Shubin, Ted Daeschler, and Farish A. Jenkins Jr. determined that a 375-million-year-old fossil they eventually named *Tiktaalik roseae,* meaning "large freshwater fish," represented a bridge species between fish and tetrapods (four-limbed animals). *Tiktaalik roseae* has scales on its back and fins with webbing, like a fish, but has adapted a flat head and neck. In the fin can be seen structures on their way to becoming various parts of an arm, including a shoulder, elbow, and wrist. Fundamentally, evolution is the story of unfolding adaptations.

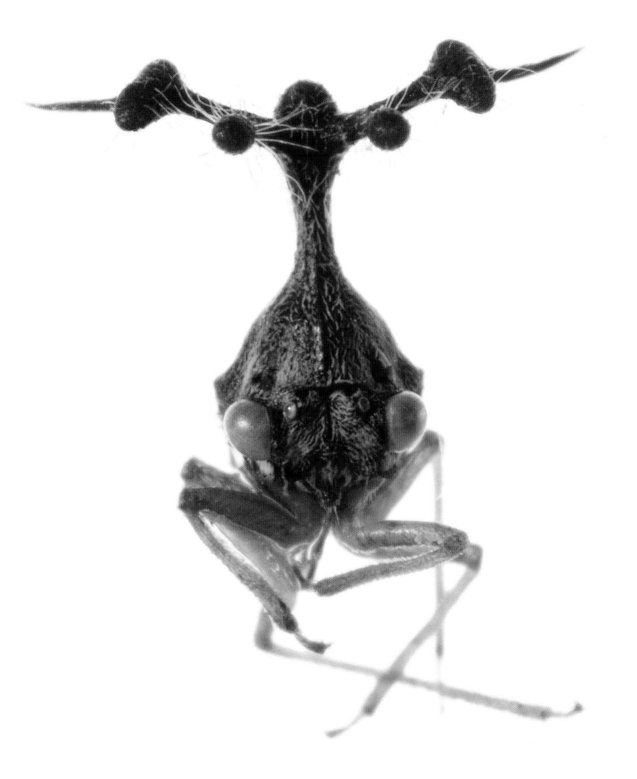

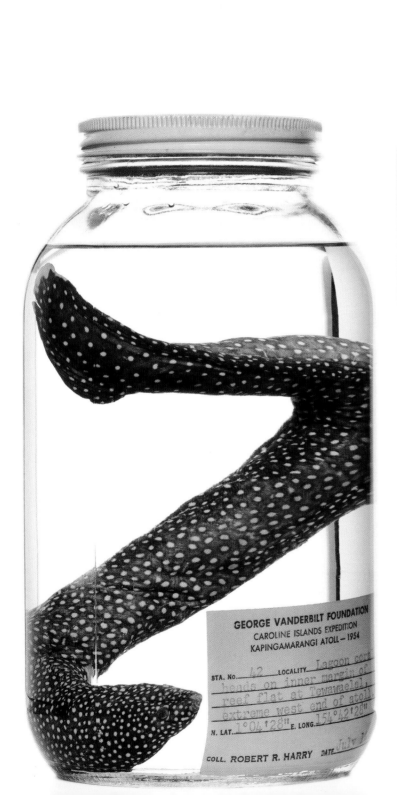

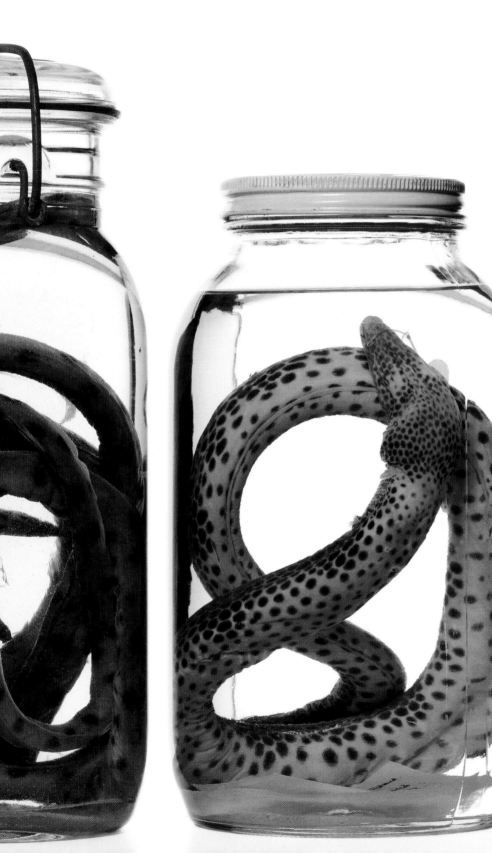

Pages 46–49: Snakes are reptiles and eels are fish; when separate taxa have adapted similar body plans, it is called convergence. The eel on the far left is *Gymnothorax melagris*. The snakes on the next spread have been recently collected from Burma and have yet to be accessioned.

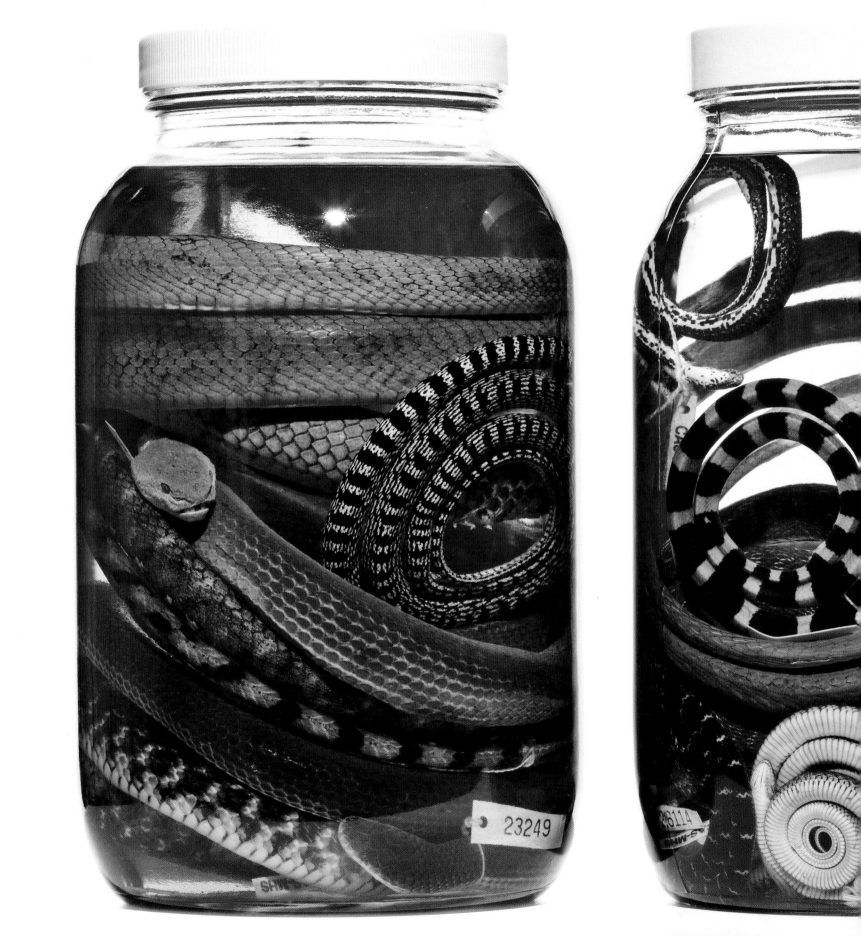

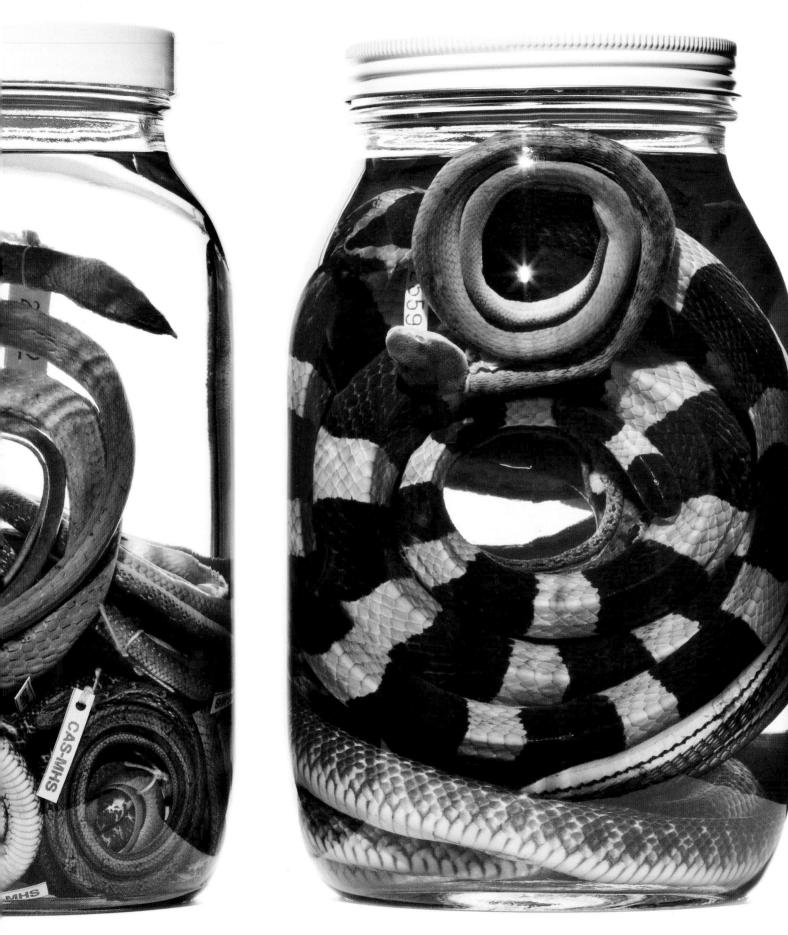

THE SANDS OF TIME

Every organism is uniquely adapted to the physical forces that shape its environment. Birds, fish, and insects all use hydro- or aerodynamic strategies to cope with the vagaries of their world. Sand dollars perfectly illustrate this story of adaptation. Sand dollars live relatively close to the shore in big colonies in almost all oceans, where the action of waves and currents is turbulent and strong, and they have evolved a multitude of strategies for staying put. It is one of nature's deceptions that the sand dollar's clinging grasp on the sand looks natural and passive, because it is a model of hydrodynamic engineering and works tremendously hard to stay where it is—amazingly, without expending much energy.

Sand dollars' flattened shape helps them resist both lift and drag, as they burrow themselves into the sand in defense against the flow of water above them, and when young they increase their weight by taking in granules of magnetite selected from the sand around them. As sand dollars mature, they build permanent weight belts, pillars of calcite between their upper and lower surfaces. The sand dollar's low central dome not only helps it to burrow, but gives it a low profile, to reduce drag. But the sand dollar's shape generates lift in the same way an airplane wing does: As fluid flows over a wing, pressure under it increases relative to the region above it, pushing the wing, and therefore the entire airplane, upward. What is good for a plane, however, is bad for a sand dollar. So shallow depressions on the sand dollar's underside provide channels to dissipate sand and water pressing from below; excess flow is then directed to indentations on the margin, where it disperses the lift forces without upending the sand dollar. In some species, the indentations along the margin have become very deep, making it easier and quicker for the pressure of the water to pass upward and zero out the lift.

A sand dollar wants to stay in place because here is where it makes its living—in the sand. Eating it, to be exact. In the upper few millimeters of sediment on the bottom of the ocean, each sand grain is a veritable garden of nutrients, covered in diatoms and bacteria and other organic material that has drifted downward from the dynamic fish and plant activity going on throughout the ocean. The sand dollar thus makes use of nutrients that otherwise would remain unavailable to the overall ecology of the environment.

Again, belying its benign, childhood-evoking demeanor, the sand dollar has some major equipment tucked away in its test, which is the thickest part of its center. In *The History of Animals*, Aristotle correctly described the sand dollar's set of five convergent teeth, which he likened to "a horn lantern with the panes of horn left out"; this remarkable contraption at the center of the sand dollar's body has been called "Aristotle's lantern" or "lamp" ever since. The sand dollar's tube feet (an adult can have up to a million on its oral surface) have sticky suckers that pass sand in a bucket brigade from one to the next, until the grains reach the mouth, where Aristotle's lamp pulverizes them.

In the meantime, those tiny spines covering the sand dollar's body are doing their part. Mounted on miniscule ball-and-socket joints, they perform different tasks. The spines around the perimeter of the sand dollar are the longest and, in general, sweep sand to keep the way clear for the sand dollar to move and to prevent it from getting clogged up. The spines on the lower surface function as levers for movement; in perfect synchronism they swing in an arc and move the organism. On the top, club-shaped spines with expanded tips form a canopy to prevent sand from settling into the spaces between the spines.

So while the sand dollar is about evident stillness and staying put, the way it achieves this is through constant and complete motion. The sand dollar manipulates its environment, using its spines to jiggle the sand around it and make it move as if it were a liquid. Sand and water mixed form a solid, but if you have ever given a sand castle a gentle pat to tidy it and had it collapse in a heap, you have experienced what the sand dollar is up to—instigating "thixotropy," or liquefaction, which makes the combination of sand and water behave like a liquid when it is agitated.

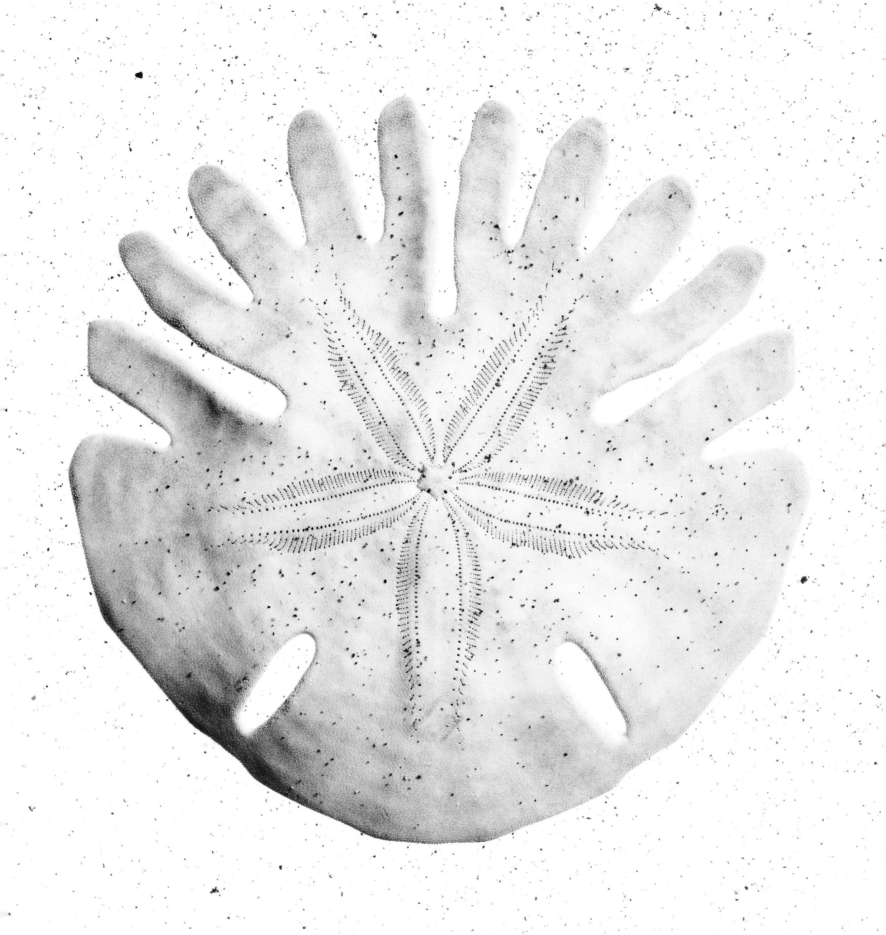

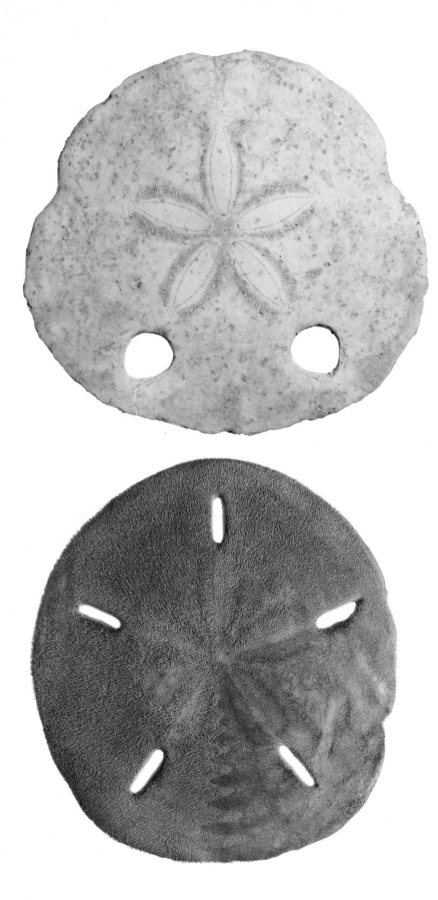

Previous spread, right: Sand dollars dine out on, yes, sand, and often still contain the remnants of their last supper when collected on the beach. The grains of sand surrounding this African sand dollar, *Rotula deciesdigitata*, had been sequestered within its test until it was prepared to be photographed.

Left: These Indo-Pacific sand dollars belong to the family Astriclypeidae; *Amphiope bioculata* is a fossil; *Astriclypeus manni* still evidences the velvety appearance of living sand dollars, which is created by skin-covered, microscopic spines all over its surface. The question of whether two lunules —yes, from the Latin for moon—evolved into five, or if it was the other way around, is part of an ongoing evolutionary puzzle. There are living sand dollars with two lunules, but long slits replace the porthole appearance here. Sand dollars stretch way back into earth history, and their phylogenetic tree has not been completely articulated, though biologists are hard at work analyzing their growth and evolutionary patterns. Nature's edits and amendments are luckily well-preserved in fossil sand dollars; the test is so durable that even ancient specimens tell a fairly complete story about how they lived.

Opposite: It looks like a shard of finely wrought ancient pottery. This sea lily fossil was collected in 1890 and is the holotype specimen of *Actinocrinus arnoldi*. Like sand dollars, sea lilies are echinoderms, and are deeply represented in the fossil record. Although they are most definitely animals, living sea lilies look like plants. They share the sand dollar's radial symmetry, and like the starfish, to whom they are also related, sea lilies uses their arms to gather food.

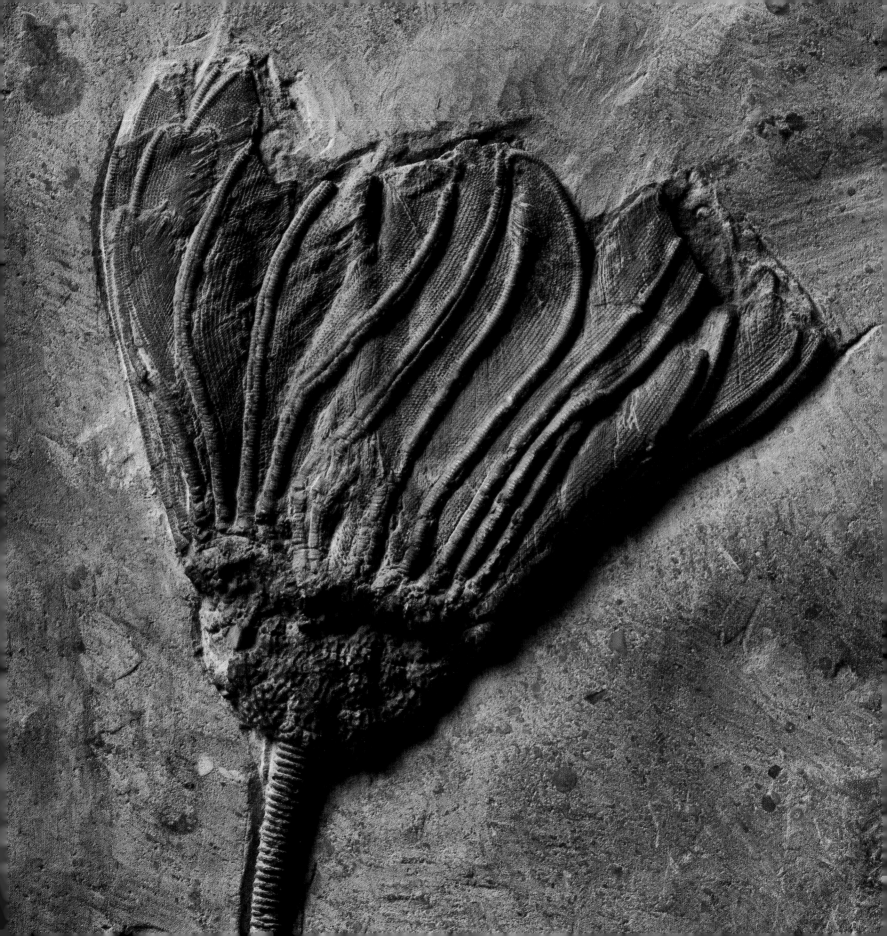

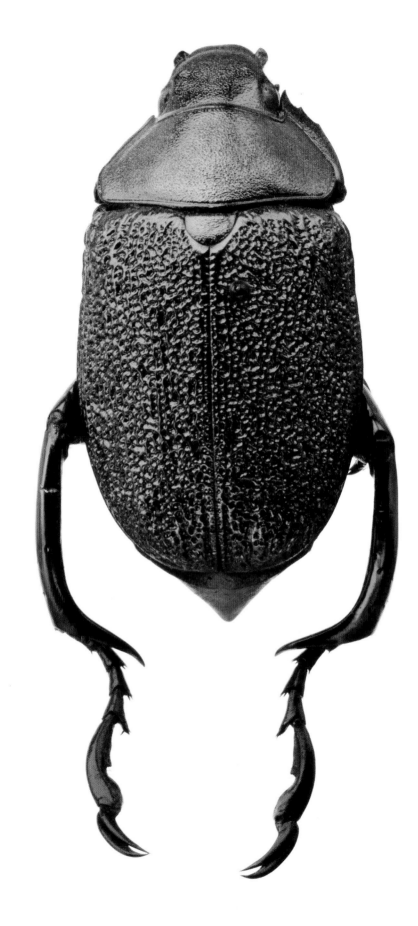

DIVERSITY

Variety not only keeps life interesting, it keeps life going. Evolution has been called a messy recipe. Simply put, variations among species are like a giant cabinet of ingredients, constantly allowing selection to try out new combinations for the most success at the moment. Usually, the more alternatives available to a class of organisms, the more likely that they will be able to adapt to a changing environment.

And the prize for most diversity goes to the beetle. With more species than any other category, and representing a quarter of all animals, these hard-cased bugs are the largest group of living organisms. The famous explanation for this proliferation was given by British geneticist J. B. S. Haldane: "From a study of his creation it would appear that God has a special fondness for stars and beetles." It could be said that Darwin shared this outsize passion, and that the beetles he collected were the true sirens keeping him from his clerical studies. "Whenever I hear of the capture of rare beetles," Darwin wrote, "I feel like an old warhorse at the sound of a trumpet."

Several factors have aided the beetle's tremendous success. Insects, in general, are an impressive category. In biological classification insects are in the arthropod phylum, morphologically defined by an external skeleton, open circulatory system, and ventral nervous system. (Humans belong to the chordates, primarily characterized by a spinal column.) Arthropods comprise 90 percent of living creatures. All of the major varieties of insects—wasps, bees, ants, butterflies and moths, beetles, and lacewings—experience metamorphosis. Essentially this is a multipart process in which the larval state of the organism develops into a differently formed adult. Complete metamorphosis evolved just once in the insect clade, way back in the ancestry of these various divergent species. Metamorphosis allows the organism to live multiple lives, capitalizing on different environmental conditions; a dragonfly naiad lives in an aquatic environment and the adult can go terrestrial.

Further defined in the taxonomical divide, beetles are of the order Coleoptera, Greek for "sheathed wing." Insects were the first organisms to develop wings and are considered the only truly winged animals: Birds, bats, and their ancestors evolved wings from other limbs. Most flying insects have four wings; beetles have given up the greater surface area enjoyed by butterflies, for example, and their front wings have evolved into a protective covering for the back ones. This allows beetles to burrow—effectively capitalizing on an enormous terrain unavailable to its fluttery relative. Wing covers also create a chamber into which the beetle's breathing pores, or sphericles, open; here, both water and oxygen can be conserved, and remain available to the beetle in dry environments, or under some other kind of duress, for up to several months. In many ways, beetles are little survival machines (and some of them, up to a foot long, are not so little).

Beetles are the world's most adept adapters, occupying almost every conceivable terrestrial niche. They first appeared in the geologic record 238 million years ago, in the Lower Permian period. Some have since made a living as herbivores, others as predators, parasites, or scavengers. Still others have found a niche at the bottom of the life cycle. Science has its own FBI—fungi, bacteria, and insects—the primary organisms that break down and metabolize plant and animal material and make it available to other living things. Without such organisms breaking down dead matter, the Earth would soon be overwhelmed with it.

Pages 54–57: Many beetles go to great lengths to hide themselves, some even mimicking animal feces. This regiment of *Chrysophora chrysochiora Latr.*, metallic and showy, may have worked out a strategy to glisten like raindrops in a dense, tropical rain forest. The beetle's covering is remarkably strong. It is lined with elastin at the joints, helping it to bend and move when need be.

The FBI all help in creating environments that have a multiplicity of niches for organisms to thrive in. Beetles are important in recycling wood, which they don't actually digest. Fungi and other organisms take up residence in tunnels bored by beetles in dead wood, allowing decomposing to go on from the inside of the wood as well as from the outside, speeding up the process considerably. There is a beetle that can eat metal cable. In mountainous Papua New Guinea there are up to twenty-five species of beetles providing a habitat for vegetation that lives on their carapaces, earning them the moniker "garden beetles."

The role beetles play in keeping virtually all ecosystems going may be part of their centrality to world mythologies and symbolism. Ancient Egyptians considered the dung beetle to be reenactors of their own life in miniature; the beetles bury balls of dung, from which eventually arise a new generation of beetles. The beetles' metamorphosis, including a pupa stage within the dung ball, is said to have inspired the development of mummification. Some historians, likening the chambered dung ball filled with larva to mummified remains in the pyramids, credit beetles with inspiring the ancient chambers that sequestered Egyptian dead in preparation for the afterlife.

Opposite: *Morpho*, of course, means "shape" or "form," and we think of it in action, as in the ability to change. Morpho is one of the names for Aphrodite, and perhaps this most beautiful of butterflies takes its name from the goddess of love. The iridescent blue and white colorations are the result of light reflecting through the butterfly's scales; a South American species, these butterflies can disappear into glints of tropical sunlight.

Overleaf, right: *Ensifera* means "sword bearer," and the beaks of these sword-billed hummingbirds (*Ensifera ensifera*) are longer than the bird's body; they groom themselves with their feet. *Ensifera ensifera* feeds on the nectar of passionflowers with deep spurs. The coinciding development of features that help organisms make a living together is called coevolution.

Pages 62–63: Presented with the Madagascar star orchid (right) in 1862, Darwin noticed its incredibly long spur and opined that there must be an insect with a proboscis long enough to penetrate to its nectar. The *Xanthopan morganii praedicta*, or hawk moth (left), with an eight- to fourteen-inch proboscis, was uncovered in 1903.

BUTTERFLIES ARE FREE

The beetle is of the earth and the butterfly the sky; the beetle's primary metamorphic association is to the death phase of life and the butterfly's is to rebirth. Lore having to do with butterflies is generally of a lighter tenor. The Greeks associated butterflies with the soul free of the body. In many tellings of her doings with Cupid, the goddess Psyche is connected with the butterfly; "psyche" finds translation as both "soul" and "butterfly." Where beetles do organic heavy lifting in the soil, and have adapted multiform strategies as both predator and prey, butterflies don't hurt a single thing (though in their caterpillar stage, they do great damage). They simply pollinate flowers. While most of the pollinating that goes on is accomplished by other organisms—bees, mostly, but also beetles, flies, birds, and even small mammals—butterflies often help create vibrant environments of flashy attraction, nature's own Las Vegas strip.

After beetles, butterflies are the second largest order of the animal world: There are approximately 110,000 species of moth and twenty-four thousand of butterflies. And butterflies are all about the sun. In the Arctic, tiny butterflies hover not more than two feet over the ground to capture radiating heat; the magnificent blue morpho reflects rather than absorbs the intense sun of its tropical environment. Lepidoptera, a type of moth, which is an insect closely related to butterflies that occupy the same order, are mostly night fliers, fluttering maniacally to generate approximately the same amount of heat a basking butterfly enjoys in the day. Moth bodies tend to be larger in relation to the wing than butterfly bodies; in most species, the difference can be told in the antennae, which are plain, tapering, or feathered on moths and knobbed at the end on butterflies.

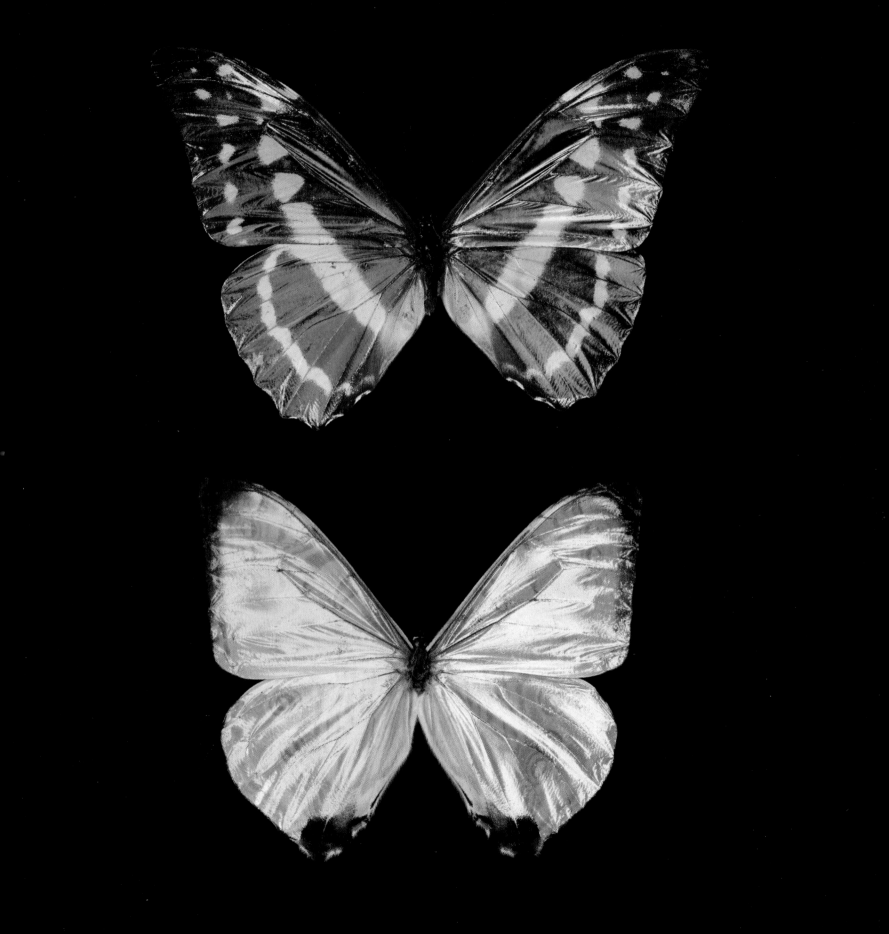

COEVOLUTION

The great success of butterflies and moths partly has to do with their ability to use the defense of plants to their own advantage. Some butterflies have developed a biochemical response to toxins and repellent chemicals in plants, and are able to metabolize them without harm; others have actually coevolved with specific plants to capitalize on the toxins and use them against their own predators, mostly birds. Much butterfly coloration is a signal to predators that the insect is toxic, or pretending to be—many butterflies simply copy the coloration of brethren who are actually poisonous.

The contemporaneous development of traits in one species relative to a complementary trait in another species is called coevolution. The need for it goes back to the primary conditions of an organism's life, the need to obtain food, to "make a living," and to avoid being made someone else's supper. The butterfly's affinity with sunlight coevolved with the daily opening of flowers to the solar rays that makes nectar accessible. Strategies like becoming poisonous to one's predator, or just looking like it, are variants on the theme. Some butterflies defend themselves by displaying big "eyespots" that can look like the beady stare of an owl; the eyespot intimidates a predator or, at the very least, draws its attention away from the vulnerable center of the butterfly's body.

SEXUAL SELECTION

Butterfly wing patterns and color have another function: to signal to others of their own kind for mating. Every organism has twin reasons for being: to survive and to reproduce. While the features and habits of any species adapt it for success at living, in nature's terms, all is for naught unless little ones are produced. Natural selection and sexual selection are thus two halves of the evolutionary whole.

Logically, natural and sexual selection ought to work together to perpetuate a species, but they are often at odds with each other's aims. Probably everyone has at one time or another been impressed with male bird plumage, like the dense and intricate feathers of pheasants. This beauty is useful only to attract female pheasants; for virtually every other survival purpose, it is a liability. Easy to spot by a predator and carrying a cumbersome load of frippery, the male pheasant is walking a razor's edge between getting by in the world and prematurely leaving it as someone else's tidy snack.

Darwin mulled over the question of beauty and wondered if the female sex might have an intrinsic aesthetic drive to transcend functionality. In *The Descent of Man* he pondered the fact that it was easy to understand why males would evolve heavy-duty weapons, like horns, with which to fight one another and fend off predators, even though they were expensive to maintain in terms of metabolic investment and heavy to carry when their possessors needed to move fast. Less obviously useful forms of male beauty are, on the surface, absurd. Darwin once again cut through the cant of his day to propose that males are pretty because females like them that way. Since beautiful males go on to have more children, this makes up for the liabilities of being a show-off with a heavy suitcase in the natural jungle. Darwin's idea that females—passive, delicate ornaments themselves, in the Victorian eye—actually drive the process and make the choices when it comes to sex was neglected until fairly recently. Of course, he was right.

Darwin wouldn't have used the term, but evolutionary biologists after him have described sexual selection as an "arms race" in which the slightest competitive advantage is topped by the next one. In this scenario, the female pheasant may have preferred pretty tail feathers for some arbitrary reason. Maybe the possessor was healthier. But when males with longer, fuller feathers produced more offspring, the resulting male progeny, "sexy sons," also had long, full feathers. From the female's point of view, she was producing sons who were likely to have better reproductive success themselves. So the tail feathers kept getting showier, until the liabilities of owning them began to outweigh the advantages. As with the Red Queen hypothesis, inspired by Lewis Carroll's *Through the Looking-Glass*, the evolutionary arms race equally characterizes the pressures of natural and sexual selection. "Now *here*, you see," the Red Queen says to Alice, "it takes all the running *you* can do, to keep in the same place," which means that to win this race, you have to do more.

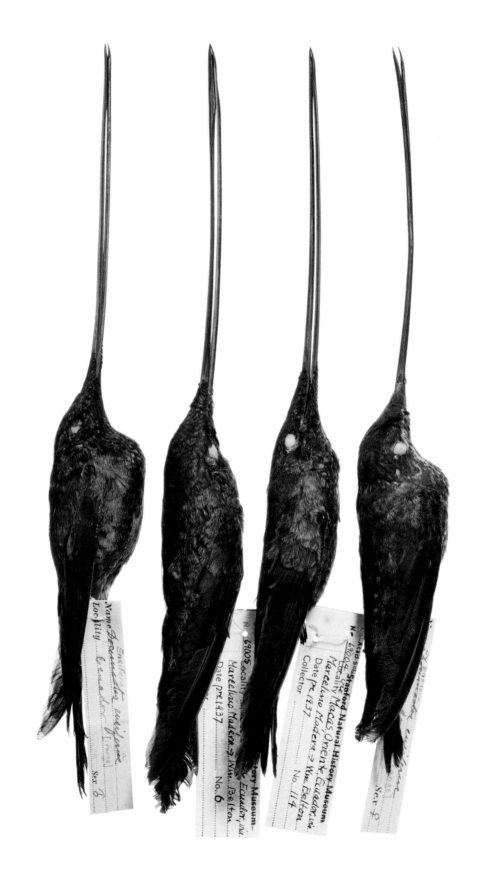

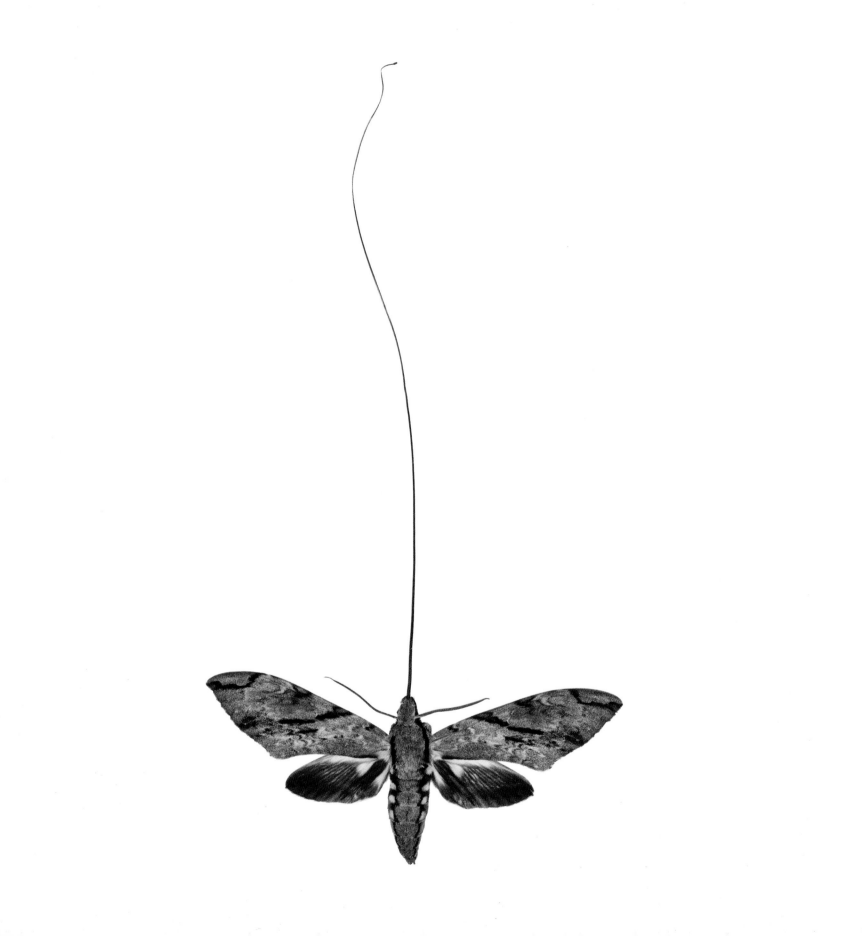

CALIFORNIA ACADEMY OF SCIENCES
Plants of Madagascar

Orchidaceae

Angraecum

Fianarantsoa Province. About 5 km NW of the main
entrance to Ranomafana National Park on the road to Vo-
hiparara.
Elev. 1037 m 21° 14' 43" S, 42° 23' 48" E

Rainforest on steep slopes down to the Namorona River.

Epiphyte with dangling branches to 3-4 dm long. Sepals
and lobes of lateral petals yellow, the lip and column
white.

F. Almeda **8045**, 6 November 1998

Expedition members: F. Almeda, T.F. Daniel, P. Fritsch
G. deNevers, S. Hanitriniaina and A. Lehavana

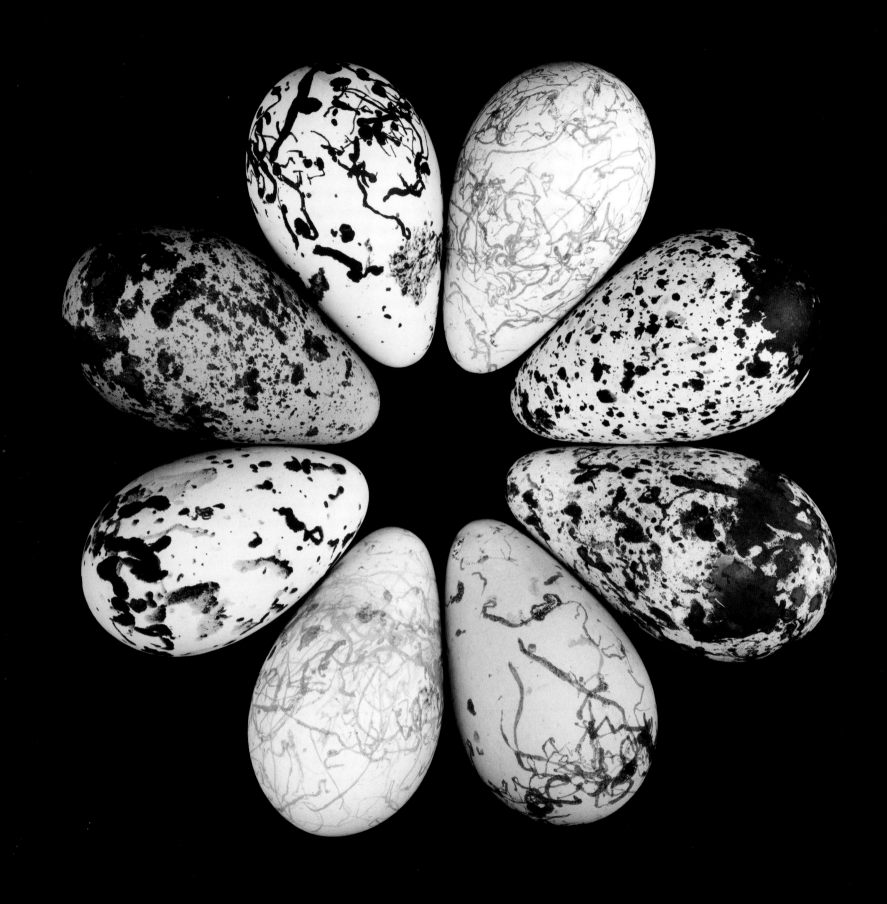

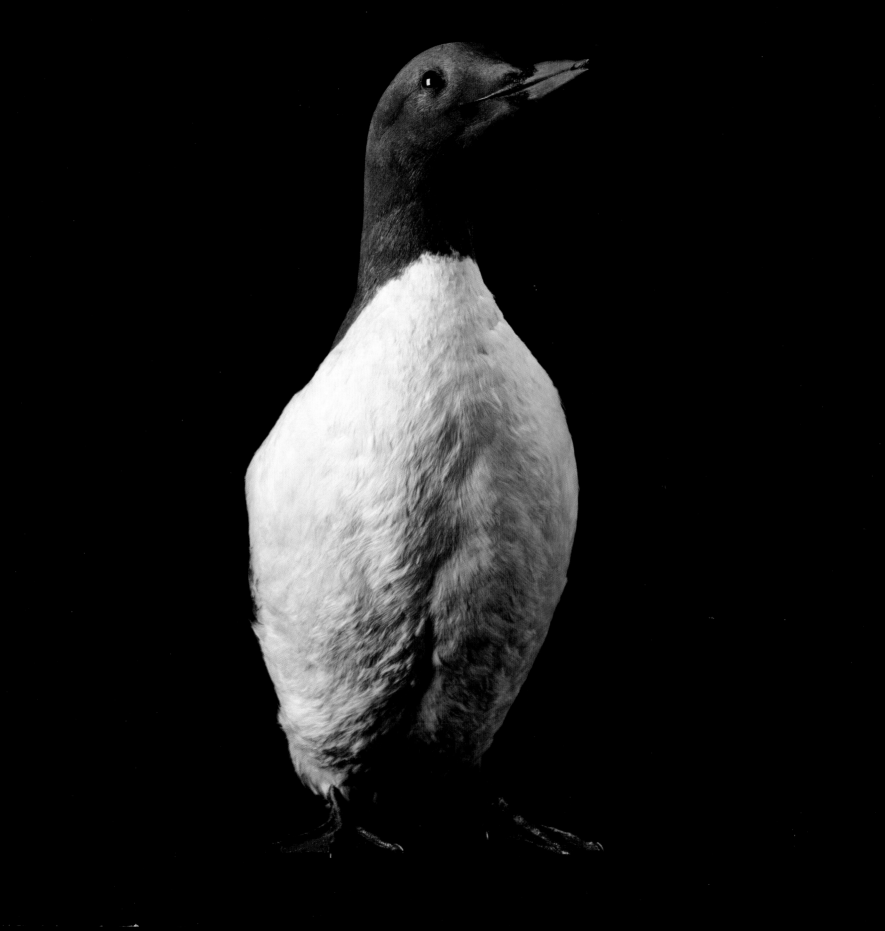

Previous spread: A once-proliferant seabird, murres have suffered human depredations since the Gold Rush, becoming nearly extinct due to a thriving "egging" business toward the end of the nineteenth century, and again pushed out of their habitat by an oil spill in the 1980s. Murre eggs are pyriform in shape and thus roll in circles, adapted to the steep, rocky cliffs where they are laid. Eggshells receive pigment when they enter the bird's uterus; if the egg is stationary during this pass, the pigment produces spots; if it is moving, the egg is streaked.

Opposite: Some sharks have live births, but those that lay eggs produce egg cases that have evolved to survive their environments, mostly to help them stay in one place and not get cast away by currents. The leathery spiral shark egg case on the left bears the incipience of a Mexican hornshark and is embedded like a screw into rocks. The shark and ray cases next to it are a common sort of flotsam; beachcombers enchanted by their tassels, hooks, and pouchy demeanor call them mermaids' purses.

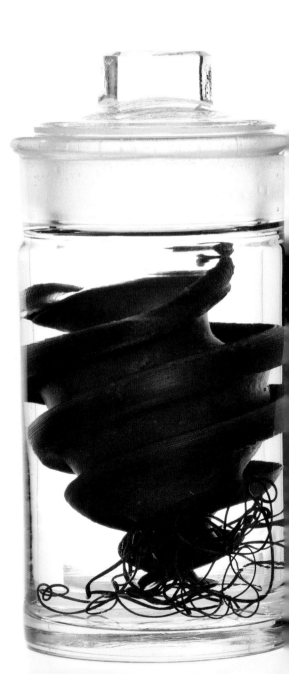

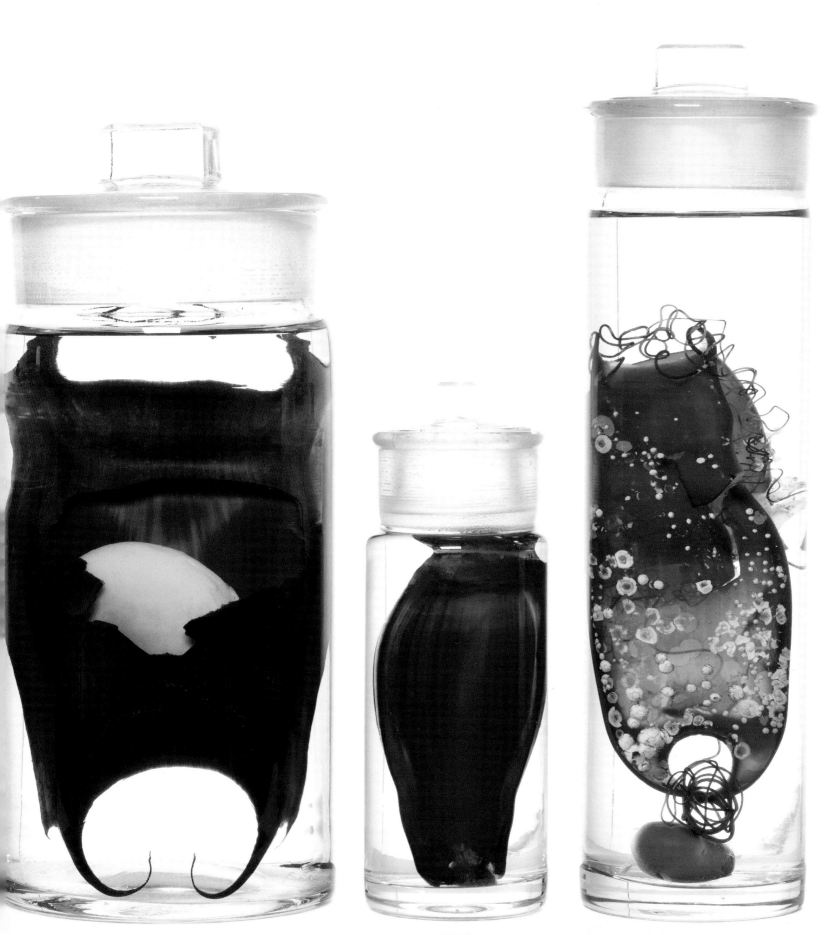

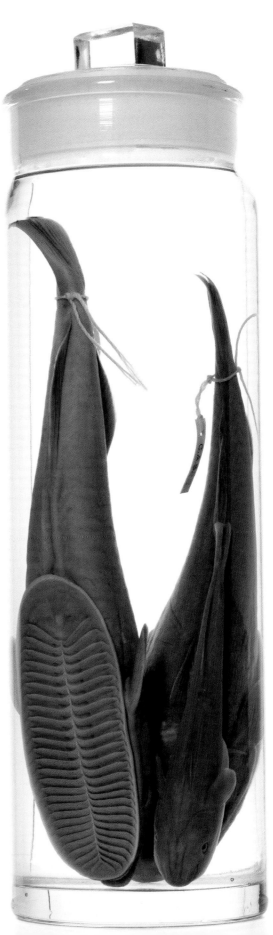

Right: The remora's suction device, with which it hitches a ride on larger fish, is an adaptation of a dorsal fin, on the top of the organism's head.

Opposite: This angler fish, also known as a "sea toad" or *Barthychaunax coloratus*, was recently collected by Monterey Bay Aquarium researchers using a remotely operated vehicle called the Tiburon. The female anglerfish sequesters a lure between her eyes, evolved from the first dorsal spine. When the fish sees prey, she extends the lure, which impersonates a shrimp. The unlucky mark that goes for it gets swallowed in one gulp. The girl is all jaw.

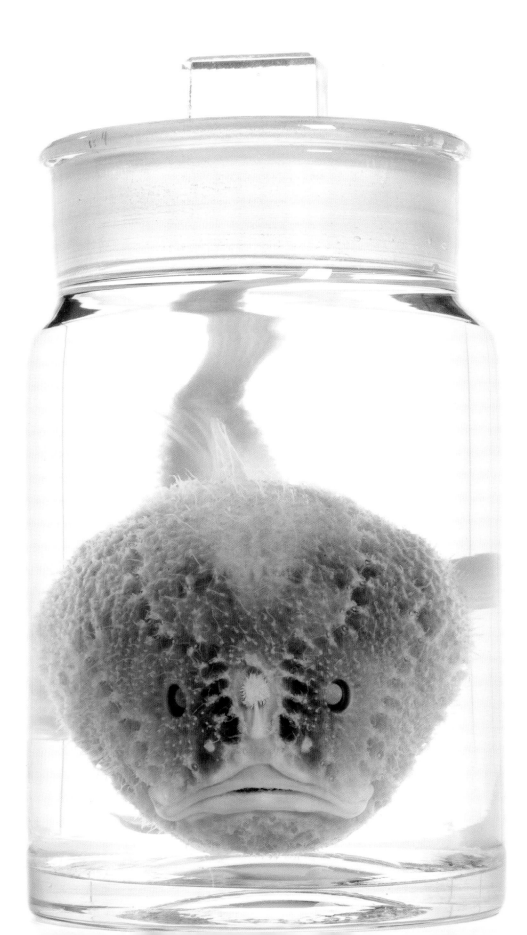

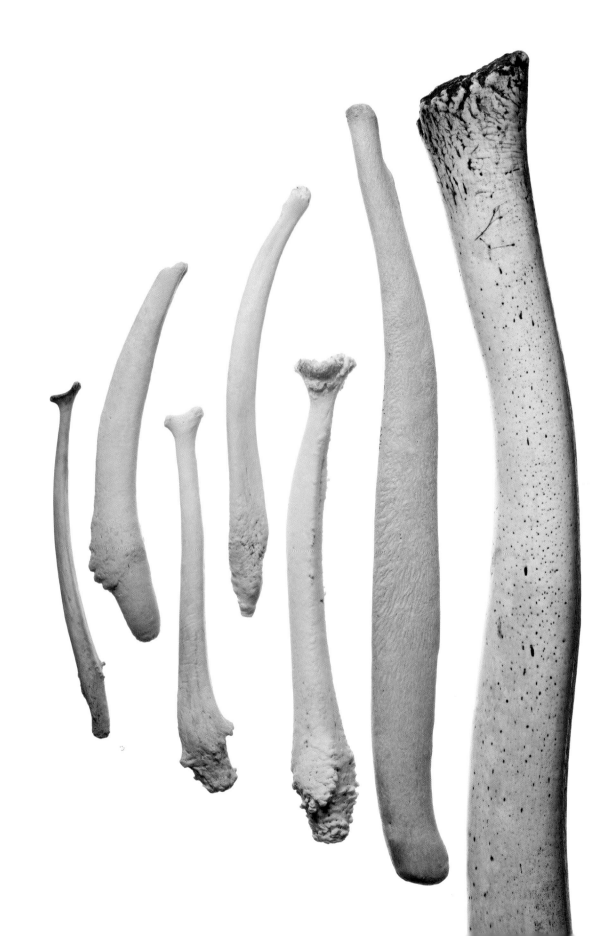

Left: Those snoozing through vertebrate anatomy class are likely to liven up when the subject turns to bacula, bones found in the penises of most mammals. An aid to reproductive efforts, when not in use the structure is otherwise a hindrance and usually retracts into the male's body. Hominids, like us, do not have them, but other primates do, as do rodents, insectivores, carnivores (like cats), and chioptera (bats). On the left are an array from marine mammals: fur seal, harbor seal, California sea lion, sea otter, stellar sea lion, elephant seal, and walrus; and on the right are those from a polar bear, brown bear, black bear, raccoon, coyote, sun bear, grey fox, and red fox. The size of the bone is not in proportion to the animal's; the walrus sports the biggest baculum of all, though elephant seals are larger creatures.

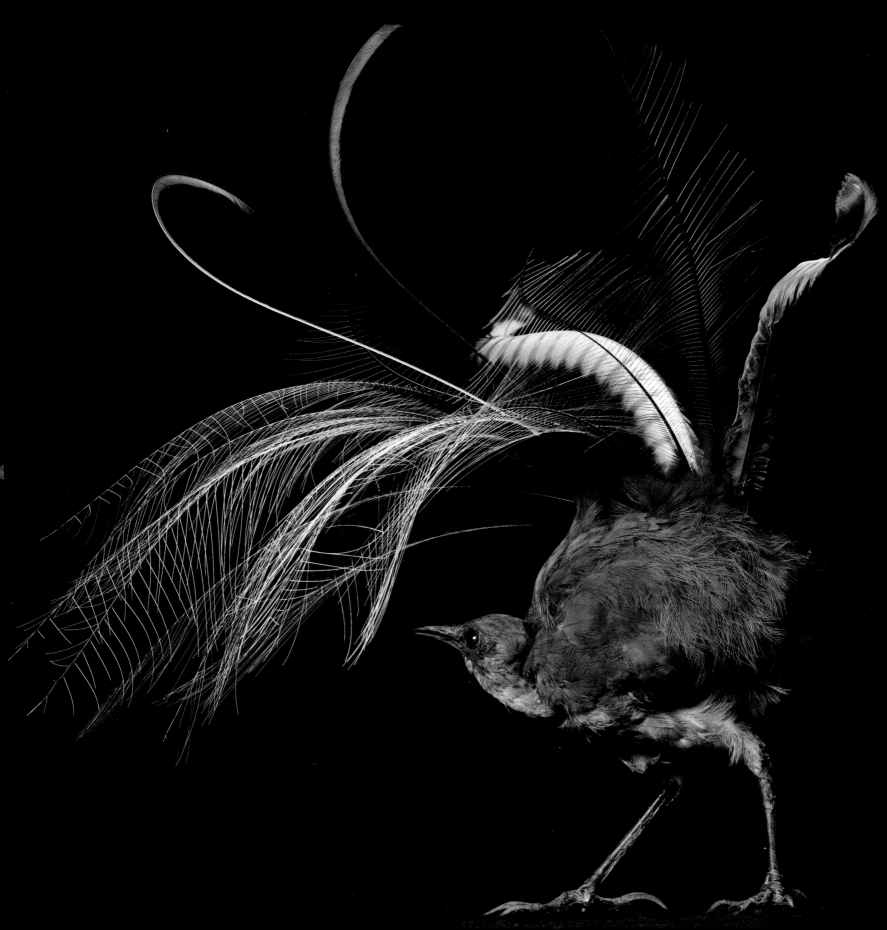

A SONG OF LOVE AND DEATH

Linnaeus catalogued plants according to stamens and pistils, the male and female sexual organs. For this he was reviled; even Johann Wolfgang von Goethe called his method a "dogma of sexuality" and worried it would discomfit female readers of his textbook. (The idea of sensitive females having to be shielded from the vulgar facts of life has, of course, been a cultural mainstay for centuries.) In the late 1940s, A. J. Bateman published a paper in *Heredity* arguing that the behavior of *Drosophila melanogaster*, a fruit fly with as many as two thousand subspecies, showed a biological basis for the prejudice. Males, Bateman asserted, had evolved to be lotharios, spreading their seed as wide and far as possible, whereas females, naturally restrained by the relatively small number of their eggs, only need one sperm for fertilization. Bateman's principle thus posits that sexual selection is a matter of males competing with one another for access to females, which drives female choosiness about with whom they will mate.

Since males do vie with one another over females, and since females are indeed selective about their partners, Bateman's principle seemed right enough. Then, in the 1980s, molecular work came along and it was possible to determine who, exactly, had fathered whom. The results were surprising. Not only did they show that hardly any species of female produces one-guy kinds of gals, but that females who mate with a larger number of males have more offspring. The "more offspring" part is the winning ticket of natural selection. The females of most species are, in fact, on the promiscuous side, and employ a variety of feints and strategies not only to partner more frequently with many, but also to obscure the fact.

A female who successfully mates with more than one partner increases the genetic odds that her progeny will have the resources it takes to survive their own generation. This, of course, is where male and female interests diverge. The male wants to procreate, and if he is going to invest resources in the resulting generation, he damn well wants to know they're his kids. Luckily for the females of the animal and plant kingdoms, their male counterparts haven't evolved the DNA tests employed by *Homo sapiens* to figure out if junior really inherited grandma's nose or if it just looks like it. Unfortunately for those females, other strategies have been devised. The damselfly penis, for example, has an inflatable bulb and two horns on its tip, as well as long bristles down its side; the male scours out sperm deposited by the female's previous consort before endowing her with his own.

The very big deal many males make out of courtship equally has to do with attracting the female and warding off competitors. The lyrebird is a case in point. There are two species of this most vocal and precise of wooers, the Superb and the Albert's lyrebirds; both live in eastern Australia. Every day of the lyrebird's winter breeding season, he gets up before dawn and visits five or six display sites; the Superb lyrebird makes his own and the Albert's finds his in situ. At each mound, the lyrebird commences a prolonged imitation of the other species of bird who live nearby: It takes the lyrebird six years (they live to thirty) to perfect this art of sounding just like parrots, kookaburras, yellow honeyeaters, and more, and some lyrebirds have been reported to imitate whole flocks of other birds going past, wing beats and all. He performs these song cycles to establish his territory with those he is copying. Part of his performance includes dancing up a storm, hopping up onto low-hanging vines, and making a ruckus amid trees and foliage. After a few rounds of this he takes a break, snacking on roots and bugs, and then goes to his next platform, where he

Opposite: No flamenco dancer ever pulled out as many stops as our lyrebird, *Menura novaehollandiae victoriae*. In the culminating stages of his elaborate mating dance, the lyrebird tosses his feathers up over his head. The resulting shape, and his wonderful music, give the bird its name.

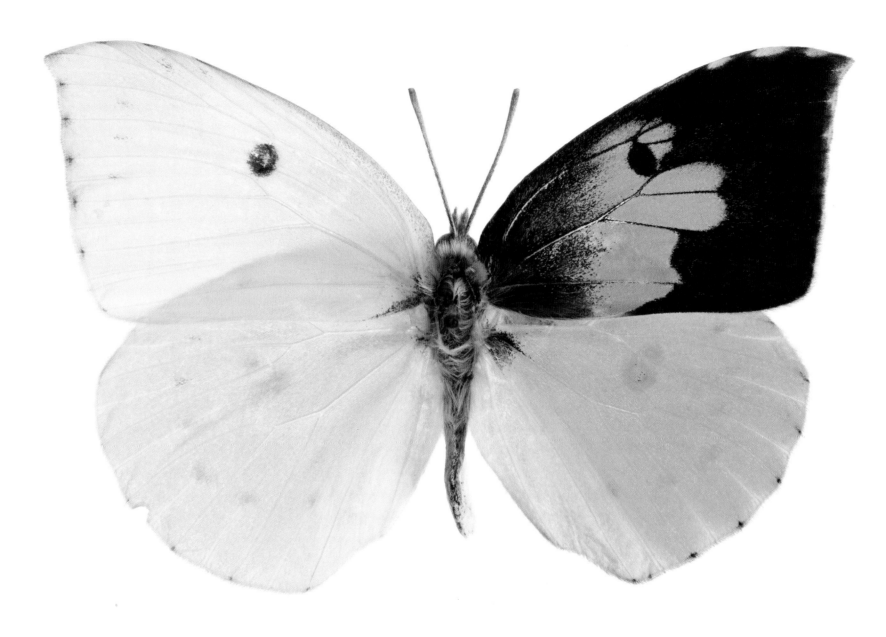

performs again. Lyrebirds mate only once every two years, so despite this great show, the female may still walk away; otherwise, the actual deed of conquest—well-deserved—takes place near one of the mounds.

Without a doubt, sex is competitive, and for very good reason. Diversity is the leaven of life, and sex creates diversity by mixing up the gene pool. Genes, of course, are the building blocks of every living thing, and as Gregor Mendel showed so long ago, sexual recombination results in an inheritance half from the mother and half from the father. Dominant and recessive gene combinations result in different appearances, but whether their effects are seen or not, an individual's genes are drawn upon for subsequent generations. New combinations are bets hedged against future contingencies. A Red Queen race is being run by every organism, creating an environment full of unforeseen threats and opportunities. For example, it is surmised that sickle-cell anemia became prevalent in a population of Africans because those afflicted with it were also resistant to malaria. Because of the malaria resistance, individuals who carried the trait reproduced more than those who succumbed to the disease, but a large number of the resulting population were afflicted with sickle-cell disease. This back-and-forth between disease assailants and their targets is a stark demonstration of why life depends on diversity. It is one reason food activists are alarmed at agricultural monocultures, like hybridized corn. When you reduce the gene pool, you remove possibilities for genetic recombination, making it much simpler for a single parasite or bacterium to wipe out an entire population.

IS SEX NECESSARY?

The subtitle of James Thurber and E. B. White's 1929 book *Is Sex Necessary?* was: *Or Why You Feel the Way You Do*. A steady stream of drolleries includes the following observation: "The phenomenon of the American male's worship of the female, which is not so pronounced now as it was, but is still pretty pronounced, is of fairly recent origin." Well, wrong, because as the lyrebird so poignantly shows, males utterly depend on females if their genes are to be carried on. The title of Maureen Dowd's late-coming riposte, in 2005, is more to the biological point: *Are Men Necessary?*

The answer is that sex is more necessary than men, and even then, not always. Sex is the process by which genes from different individuals are mixed, but genes also change constantly through mutation. If there were to be only one sex, it would clearly be female. To keep any population constant, a female has to produce at least two offspring to replace herself and her partner, in an asexual context, she only has to produce one offspring, to replace just herself. Indeed this situation exists in some ancient lineages of bacteria. But species that become exclusively asexual usually wind up extinct. Even though genetic mutation can provide new materials for future generations, it isn't as effective alone as it is in conjunction with sex. *E. coli* have their own take on this situation; they reproduce asexually, by dividing into two genetically identical cells. They augment their DNA by picking up extra genes gathered from the environment, including that of dead bacteria and passing viruses. They also have nonreproductive sex, in which they exchange genetic material.

Opposite: Some hermaphrodites have the potential to self-fertilize, but the gynandromorph (from the Greek *gyn* for "female" and *andro* for "male") has no reproductive ability. The left half of this California Dogface Butterfly is female and the right half is male; the butterfly is named for the male's appearance, which is said to look like a poodle. What genetic error created this very rare mutant nobody knows. During cell division in its embryonic development, migrating sex chromosomes may have doubled up in one half of the body, leaving its complement empty.

Mammals don't include them, but hermaphrodites are very common throughout the major lineages of life. Some organisms carry both sets of genitalia their whole lives, while others change from male to female or from female to male depending on circumstances. Generally, hermaphrodites evolve when there is a better chance for them to leave progeny than if the organism is only male or only female. Hermaphrodites are in some cases able to self-fertilize, but in any case are capable of procreating with anyone, of their own kind, that they meet.

The title of Dylan Thomas's poem "The Force That Through the Green Fuse Drives the Flower" echoes the constant underlying dynamism of evolutionary processes, which, in another way of framing it, are simply the processes that define life. Even a stalk of grass is not passively, but actively existing. We can see the efforts of ants and beetles busily manipulating their environments; what is not so apparent, yet just as relentless, are the survival and reproductive strategies of literally every living thing, from microbe to flower to great ape. These strategies include adaptive traits, skills like burrowing, climbing, and flying, and they include morphological developments like our opposable thumbs. Predator/prey relationships and mutually beneficial symbiosis, as between butterfly and flower, are among the many interconnections found in all nature. Reproductive competition helps refine the gene pool and keep a species relevant in its environment. The more closely we look at the processes of life, the more immensely detailed they are revealed to be. We are part of an act of creation that is always in progress.

Opposite: The chameleon's eye takes its measure from within a protruding cone comprised of fused eyelids. Like no other animal, it can see 180 degrees around, and each eye operates independently. The development of complex sight is connected to brain development in humans, but the chameleon's brain is minuscule; it is likely that the chameleon restricted all other sense capacities to allow fuller processing of spatial information.

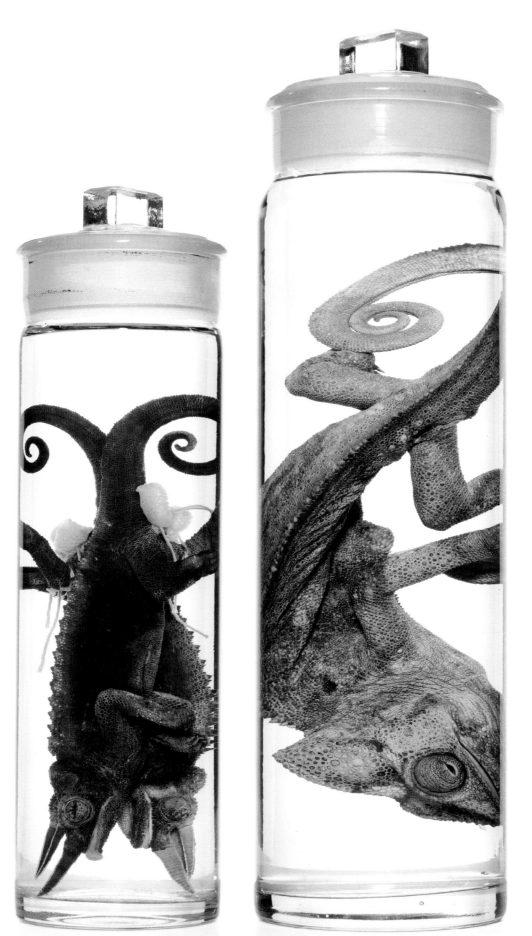

Right: The Texas blind salamander, *Typhlomolge rathbuni*, has vestigial eyespots, reminders of the ability to see, which this cave dweller no longer needs. The only known species in the Edwards Aquifer around San Marcos lives its entire life in darkness.

Opposite: The ability of a lizard to fly, or really to glide, from tree to tree, via a membrane covering elongated ribs, has evolved multiple times in the deep past. This *Draco blanfordii* is currently found in China, Malaysia, and Thailand. Fossils of extinct flying lizards have been found dating to the Cretaceous, 145 million years ago, and the Triassic, 251 million years ago.

Pages 80–85: The ammonite, an early celphalopod mollusk, employed a heavily armored shell; the protection did not prevent it from going extinct when the dinosaurs did. The chambered nautilus managed to squeak through, along with a few other groups of celphalopods, which have evolved into the cuttlefish (skeleton shown), the Spirula, the octopus, and the squid. All these mollusks share beaks and siphons and have suckers on their arms. The chambered nautilus still employs its beautiful shell, building it out incrementally as the animal gets bigger; the cuttlefish, octopus, and squid all internalized the skeleton, finding their own success in the seas, depending more on movement, camouflage, and flexibility and less on hard protection.

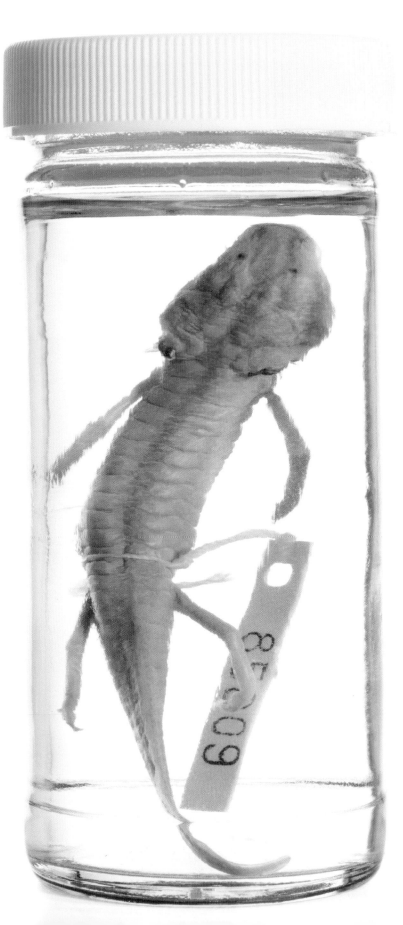

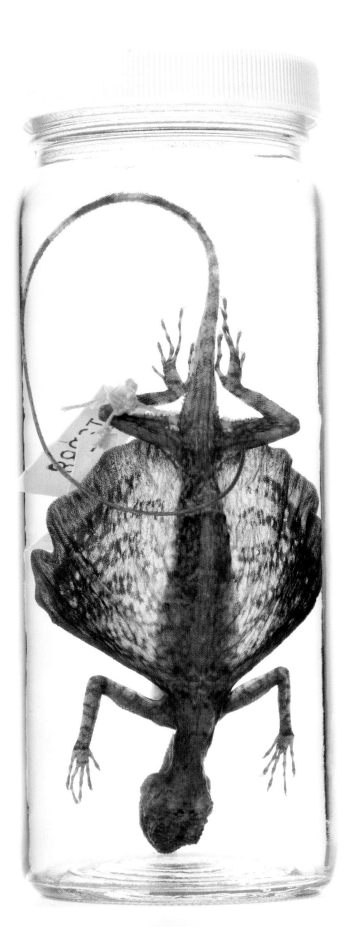

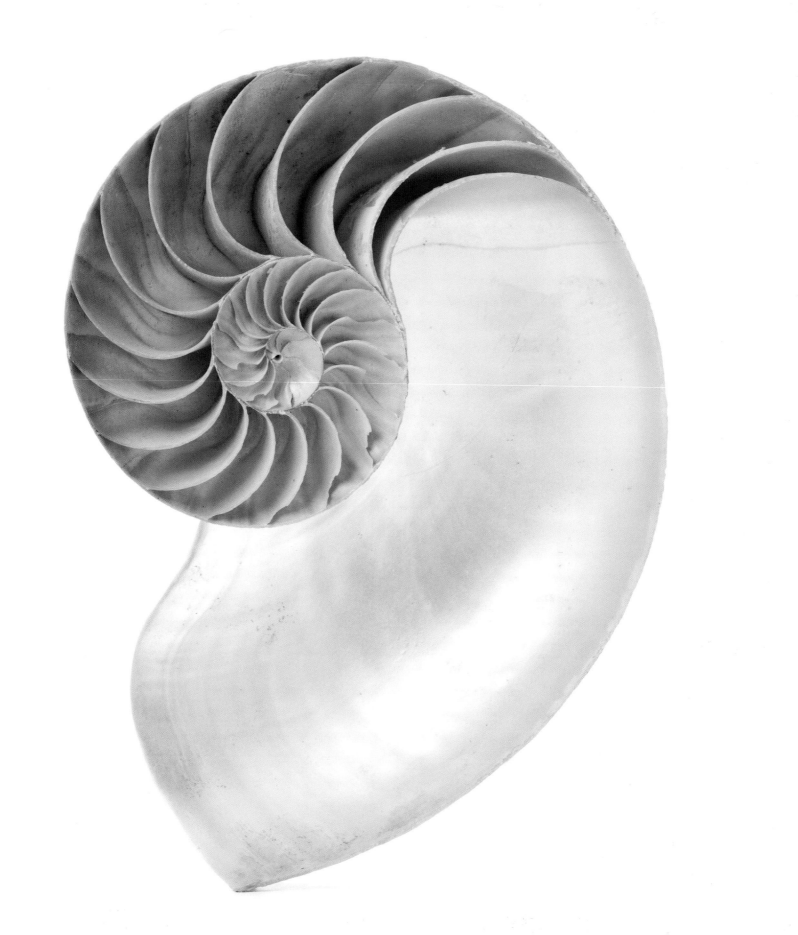

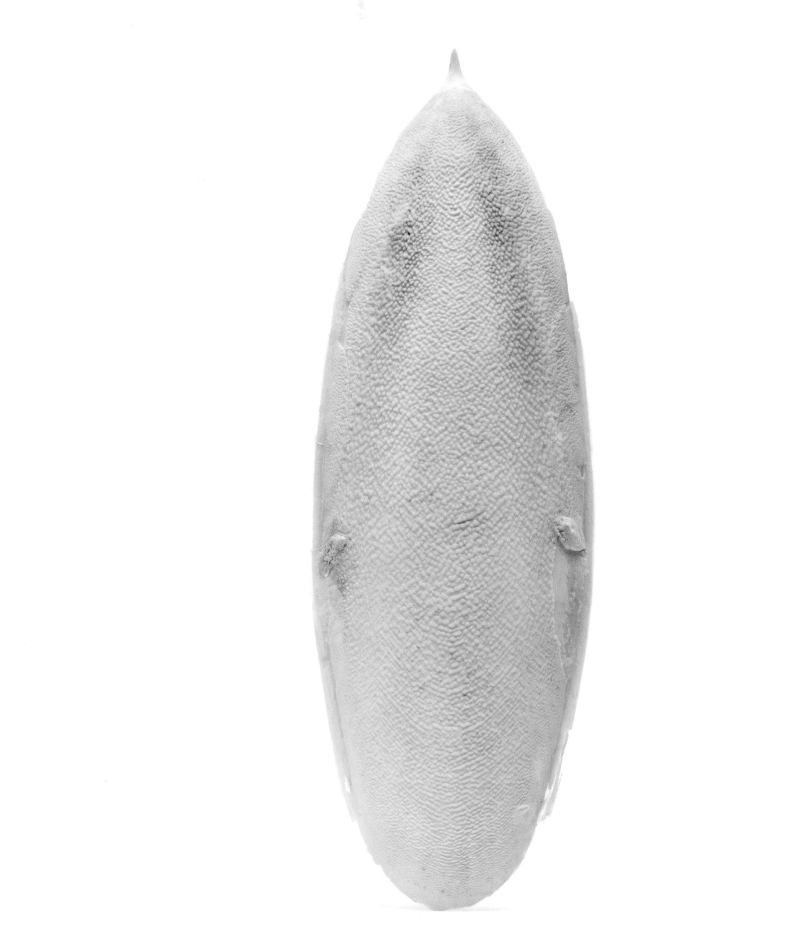

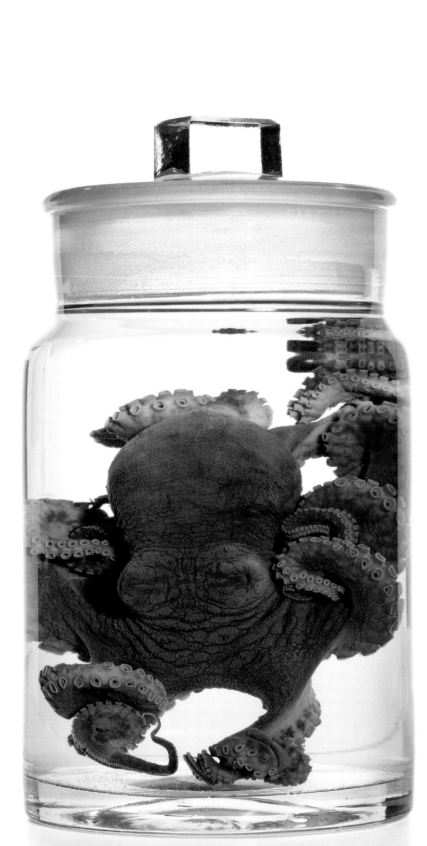
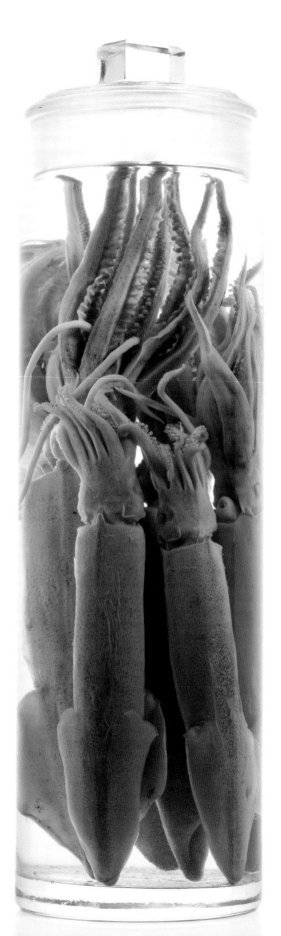

PATTERNS OF EVOLUTION

BIOGEOGRAPHY

Darwin was an agonizer. He knew full well that *On the Origin of Species* would make a frontal assault on the prevailing orthodoxies of his time. He might have been even more reluctant to publish his ideas about natural selection were it not for Alfred Russel Wallace, a naturalist/explorer in the great tradition of the nineteenth century. In 1858, Wallace sent Darwin his paper, *On the Tendency of Varieties to Depart Indefinitely from the Original Type*; its thesis, a variant of Darwin's own, is summarized in a passage taken from Wallace's autobiography. One day, ill with fever, he pondered the various adaptations of species that he had observed in his travels, as well as Malthus's ideas about checks to population growth: "[W]hy do some die and some live? And the answer was clearly, that on the whole the best fitted live." Wallace concluded that adaptations emerge in response to changing conditions, "and [that] in the very process of this modification the unmodified would die out, and thus the definite characters and the clear isolation of each new species would be explained." Recognizing the similarities in their work, Darwin quickly joined with Wallace to present the concept of natural selection to the Linnaean Society. Amusingly, the president of the society later commented that nothing "striking" had been discovered that year.

Wallace is often referred to as a kind of shadow figure by the side of the vaunted Darwin; some even claim Wallace has been cheated of his rightful status as the first to conceptualize natural selection, although by most measures, including Wallace's own, Darwin's is the more comprehensive explanation of natural selection—and deserves first billing. The relationship between the two men has

its fascinations. Darwin was a moneyed man of leisure and status, with all the time in the world to reflect and write; Wallace, from scrappier stock—and despite great scientific accomplishments—was always scrabbling for financial support. Darwin seems to have felt guilty and anxious about Wallace; he knew he had the upper hand in the relationship and worried that he was exploiting the other man. Darwin and Wallace were, however, congenial and generous toward each other, and both benefited from their connection. Wallace's dimmer star is often attributed to the fact that, although he was a staunch defender of Darwin and natural selection his whole life, he put evolution within a spiritual framework and deferred to a "higher intelligence" as the ultimate mover. Darwin's response, "I hope you have not murdered too completely your own and my child," at once denounces Wallace's belief and testifies to the intimate connection between the two men and their idea.

The author of several perennially influential books (Joseph Conrad called Wallace's *The Malay Archipelago* his "favorite bedside companion" and used it as source material), Wallace is now, in a way, having his due. His 1876 *The Geographical Distribution of Animals* established the science of biogeography, arguably the most compelling context in which evolutionary biology now operates. Biogeography looks at species distribution and the relationships among species themselves and in relation to geography—who lives where, who lives next to whom, and how they got there in the first place. It also incorporates the long time scale—the fossil evidence of paleontology, the age of the Earth, the dynamism of ocean and continent movements. Its resonance today primarily has to do with conservation, as scientists seek to understand the connections among species survival, climate, and habitat.

HOW DID I GET HERE?

Early thinkers attributed the geographic location of species to divine provenance. Linnaeus, however, realized that there were too many different kinds of life for all to have been representatively safeguarded on Noah's Ark. He also noticed that countless organisms were perfectly suited to their environments, and that this was also problematic: How could they all originate from the same source? In an effort to resolve these inconsistencies, Linnaeus proposed that the ark had landed on Mount Ararat, in modern-day Turkey, and that the successive elevation zones along its slopes had housed different groups of species adapted to different environments. Once the flood receded, these species migrated, spread, and colonized the Earth.

Georges-Louis Leclerc, Comte de Buffon, the eighteenth-century French naturalist who later influenced Lamarck and Darwin, saw a big problem with Linnaeus's proposition: How could species migrate across climates and environments that were totally hostile to them? As Linnaeus named the phenomenon of ecological zones, so Buffon correctly identified the existence of environmental barriers. Buffon also noticed that similar but isolated regions have strikingly similar assemblages of plants and animals; this is known today as Buffon's Law and is sometimes called the first principle of biogeography. His solution was to propose a much more northerly origination point than Mount Ararat for all species, which would then have evolved as they spread southward. Darwin credited Buffon with foreshadowing natural selection.

Throughout the eighteenth century, Linnaeus's and Buffon's views were tested by the discoveries of gentlemen explorers, who catalogued the diversity they found in far-flung locations and brought back extensive collections to England and Europe. Variations on Linnaeus's Mount Ararat hypothesis abounded:

The different "floristic" provinces around the world were explained as multiple sites of origination—once Noah's flood receded, these plants spread. Despite their flawed logic, these naturalists noticed many of the patterns we study today, including the observations that different plant assemblages are strongly correlated with climate conditions, and that plant life is distributed along elevation gradients, from tropical to arctic.

In the nineteenth century, the idea that the Earth is a static place populated by cosmopolitan species, which can live anywhere on the globe, gradually gave way to an understanding of the Earth as dynamic, comprised of a multitude of highly specific localities and populated by organisms specifically adapted to them. Lyell, whose *Principles of Geology* so influenced Darwin, showed that sea levels themselves had changed over time (perhaps giving Noah's flood some archetypal resonance), and that the surface of the Earth had likewise been changed by the lifting up and eroding down of mountains. Against the discretely bound time frame of the instantly created world was exposed an immense time frame of gradual change. Lyell observed whole fossilized biota—the flora and fauna of a region—in rock layers, and inferred that climate change had caused these modes of life to perish. So to the idea of multiple sites of creation, Lyell added his conviction that there were successive periods of creation as well. Mistaken as he was, Lyell's work provided the best grist for the evolutionary mill: evidence of extinction. The way we organize the vast epochs of life on Earth—the Jurassic, the Mesozoic, and so forth—is bracketed entirely based on the fossil evidence of life as it existed and then ceased to exist in those time periods.

Other significant nineteenth-century observations about biogeography have become known as rules. Gloger's Rule states that individuals of a given species that hail from more humid habitats tend to be darker in color than those of the same species in drier habitats. Bergmann's Rule observes that endothermic (warm-blooded) vertebrates in cooler climates have larger body sizes than those of the same species in warmer climates; a lower

ratio of surface area to volume helps conserve body heat in the cold, and a larger surface area helps to dissipate heat when it's hot. The fact that limbs and other extremities of endothermic species in cold climates are shorter and more compact than those in warmer ones is known as Allen's Rule, and explains why polar birds and mammals thus tend to be on the stubby side. All of these patterns connect morphology with environment, a critical evolutionary nexus.

Darwin's thinking was all about patterns, and deeply informed by such biogeographical considerations, which he lays out fully in his work; but Wallace most thoroughly and methodically stated the principles of the discipline that are still relevant today. He proposed that speciation occurs as geographically isolated populations adapt to the local environment; that distant islands are colonized by long-distance dispersal (and that some organisms are better at this than others); and that, in the absence of predation and competition, life-forms on isolated landmasses can diversify. In *The Geographical Distribution of Animals*, Wallace catalogued who lived where, establishing zoogeographical regions still used today. Enumerating the factors that influenced local animal life, including elevations, ocean depths, and regional vegetation, he proposed a methodical explanation for how and why animals lived where they did and how they had taken up their residences over time.

THE JOURNEY, AND THE ARRIVAL

Fundamentally, there are two ways to explain how and why animals arrive in a new residence. Vicariance describes the situation in which some geological event has fragmented or separated an environment, thus isolating parts of the population. Over the long stretch of geological time, continents have moved apart and together, mountain ranges have pushed up out of the earth, and new ground has been created by volcanic eruptions. Populations in a species that are separated from one another eventually accumulate their own cascade of mutations, becoming more unlike their former brethren, until ultimately they can no longer interbreed. Thus, change to biogeographic distributions drives the process of speciation, providing the theater in which evolution unfolds.

Species can also arrive in new places by hitting the road themselves; in the common shorthand expression, they disperse by wind, water, or wing. In his own worldwide travels, far more comprehensive than Darwin's, Wallace took note of large, flightless birds living on islands, such as New Zealand's kiwi. The question Wallace posed to himself was whether these birds lost their ability to fly after they got to their islands, or before. How could they have arrived on their islands without this ability to disperse? Now, if they had walked, that would be a different story. Today we understand that indeed they could have walked from Africa to New Zealand by way of Antarctica, which in the Mesozoic Era was part of one big province called Gondwanaland. Wallace had no knowledge of this, of course, but he did guess that "land bridges" had once existed and since disappeared.

Previous spread, left: The industrious mountain beaver creates transitional environments in which many other animals and organisms thrive; endangered due to habitat loss, reduction in *Aplodontia rufa* populations has a cascading effect on other species.

EASY IN
THE ISLANDS

With the publication in 1881 of *Island Life*, Wallace also established the special place of islands in understanding evolution. Islands are formed in two different ways; like the Galápagos, some are created from volcanic activity and start out de novo, free of vegetation or other life, until natural erosion begins the process of making them hospitable to life-forms. Continental islands, like New Zealand or Madagascar, were once attached to a mainland at some point in the Earth's history. Life was already there when they became separate, and as with, for example, the lemurs on Madagascar, they often harbor relictual species that have gone extinct elsewhere. These islands are a particular kind of snapshot of the past, proceeding along in a relatively protected present. Lemurs still swing from the branches of Madagascar for the same reason Darwin was able to scoop birds up with his hat on the Galápagos: These animals have found a spot on the Earth free from predators.

Many plants and animals found on islands are endemic—they aren't found anywhere else. The flightless cormorant is such a case. Descended from a relative who did fly, which is probably how it got there in the first place, the Galápagos cormorant, like the kiwi, eventually lost the need for full-blown wings. It can swim, however, foraging in shallow water and diving for food. It doesn't have predators, so it doesn't need wings to help make a quick getaway. In fact, wings are what scientists call "expensive" to an animal; to sustain them requires calories, and any energy spent on metabolism is diverted from other survival mechanisms—for natural selection to keep choosing in a feature's favor, it has to be metaphorically able to pay for itself.

All vestigial structures, like the wings of the cormorant or the human appendix, once had a function; often, an organism will dispense with the structure completely, as a snake has dispensed with legs and arms. But if losing the structure altogether will compromise the integrity of the whole organism, nature keeps just enough of it to keep the body in balance. If a structure's purpose in the past has been applied to a new task, it is not vestigial but "exapted." Penguin wings are a good example, since the birds no longer fly with them but use them to navigate underwater. Vestigial structures were critical to Darwin's thinking because they so clearly evidence generational change over time.

Opposite: The flightless kiwi has the largest egg relative to its body size of any bird, and it has nostrils at the end of its beak to scent out earthworms. All kiwis are endemic to New Zealand; this one is known as the North Island *Apteryx australis mantelli*.

Overleaf: The flightless cormorant (left) is endemic to the Galápagos, where the metabolic expense of wings isn't worth it for a bird without predators. Brandt's cormorant, *Phalacrocorax penicillatus*, also has a thicker breastbone, with which to heft and stabilize the wingspan.

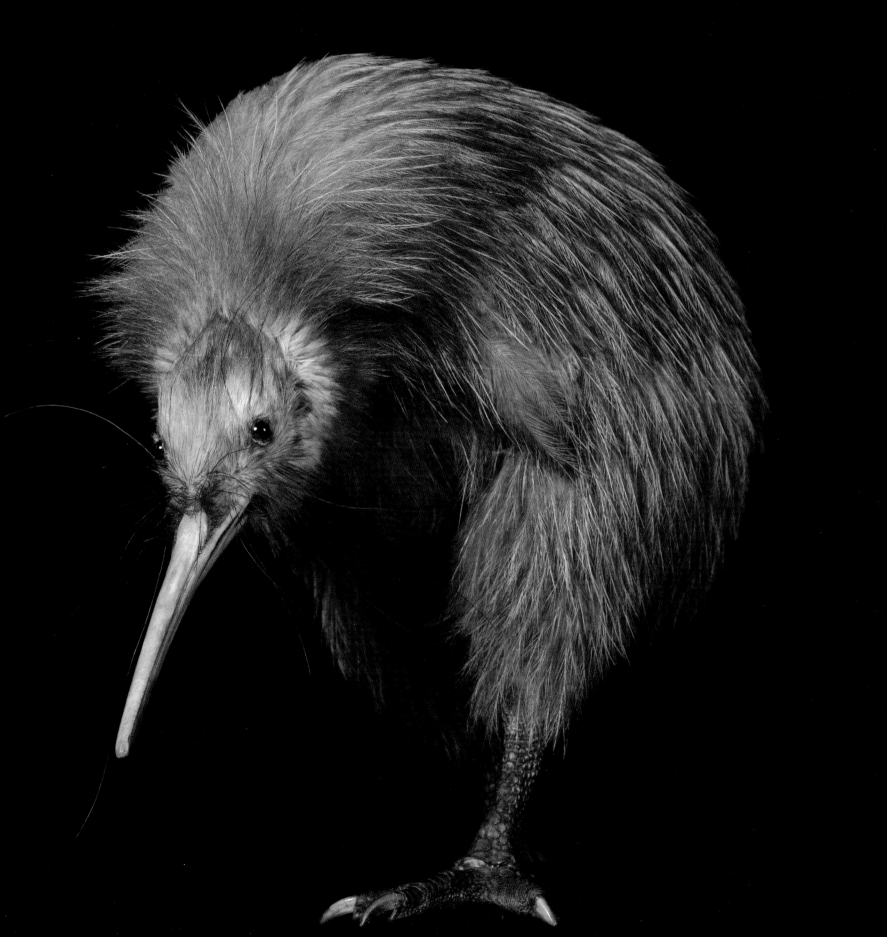

THERE'S NO PLACE LIKE HOME

Every place on Earth, island or not, has its own remarkable specificity and provides a home to a dynamic collection of organisms. Similarly, every biogeography has its own ecology and ecosystem—both terms have at their root the Greek word for "house"—and this is a multistoried affair. There are considerations of terrain, in terms of soil, rock, structure, age; of who lives there, from permeating microbes and insects to the flora and fauna; and of climate conditions. All of these elements interact to create an ecosystem that exists in a temporal context.

As niche describes the particular way an organism makes a living within this household, so habitat describes the neighborhood. The relationship, however, between organism and habitat is not a one-way street, and as habitat drives adaptation and evolution in species, so can species effect change to their habitats. After *Homo sapiens*, the beaver is said to be the animal that makes the most change to a given habitat, creating all sorts of worlds within worlds for a multitude of fellow creatures. Beavers live near streams, rivers, lakes, and ponds; they dam up water and remove trees with which to build elaborate lodges. Beavers are semiaquatic, with webbed hind feet that help them swim, and nonwebbed forepaws better suited to digging and manipulating. Beavers use their flat, scaly tails as a rudder; when they swim underwater, valves close off their nostrils and ears, and a membrane making "diving goggles" protects their eyes; they can even close their lips behind their teeth to allow them to gnaw while submerged. Beavers are so adept in the watery world that in 1760, the College of Physicians and the Faculty of Divinity in Paris declared them to be classified as a fish and permitted eating beaver meat on fast days.

As the beaver bridges two worlds, terrestrial and aquatic, so they create a "boundary complexity" that opens up new living conditions for other creatures. The water they dam up is effectively stored and available in droughts. Their industry changes water-flow patterns, reducing erosion and inviting the creation of new ponds, swamps, and meadows for a dense "tangled bank" of species to participate in. Beaver ponds can then become reproductive sites for salamanders, frogs, and toads, the presence of which further invites birds to come by, an example of organism-induced climate change that leads to increased biogeographic and biological diversity.

DIVERSITY CORRIDORS

The pressures of climate change instigated by *Homo sapiens* are changing the very parameters of what constitutes a biogeographical area and what shelters its inhabitants. At the Center for Biodiversity Research and Information at the California Academy of Sciences, Dr. Healy Hamilton is combining traditional museum practices such as taxonomy with computer modeling tools and satellite data to predict not just which species are endangered now, but which will be further threatened as the climate of their current habitats change. Hamilton uses an approach called biodiversity mapping to model what occurs where; to record information about how many endangered species there are in a given region and who they share the space with; to model how populations have changed in industrial times; and to predict what likely invasive species distributions might establish in a given region. One of her projects is in conjunction with the Save the Redwoods League.

Opposite: Habituated to wetlands, the Light-footed Clapper Rail, *Rallus longirostris levipes*, is endangered due to development along the coast of Southern California.

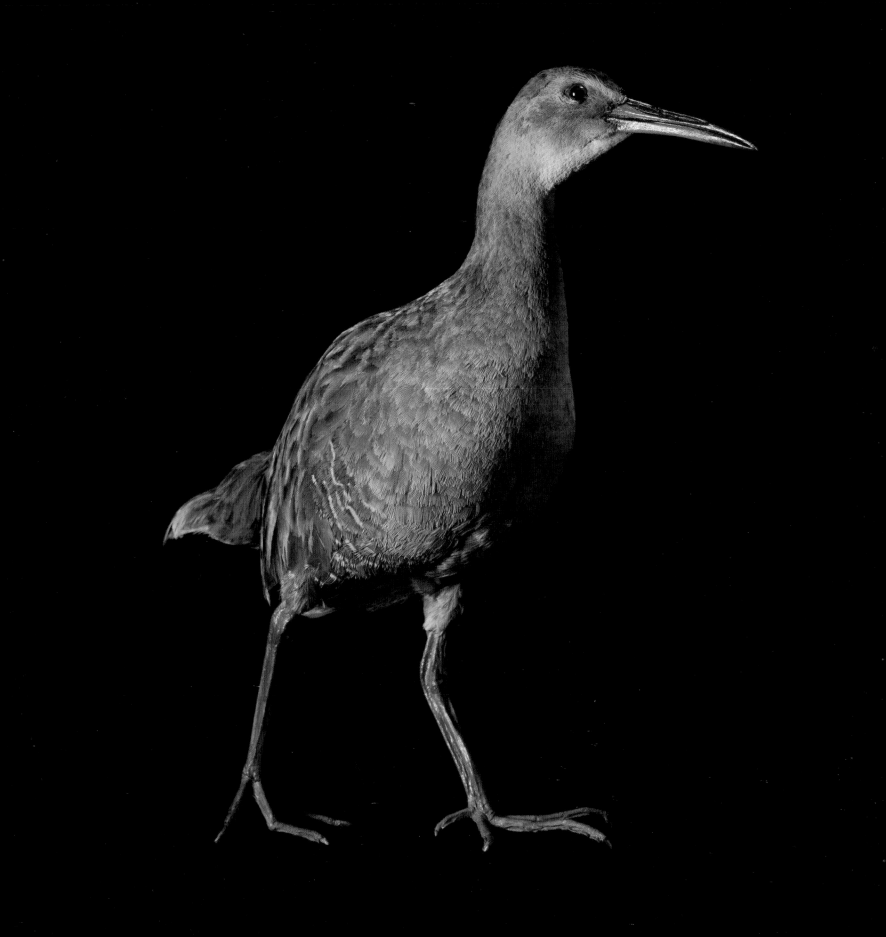

Herbarium of James R. Shevock
Presented to
California Academy of Sciences
1983

FLOWERING PLANTS OF CALIFORNIA
NORTHERN COAST RANGES

DARLINGTONIA CALIFORNICA Torr.

Occasional to common in bogs at the
headwaters of Shelly Creek along
county road 316. Section 22, R3E, T18N.
Middle Fork Smith River Drainage,
Six Rivers National Forest. Del
Norte County.

17 April 1973 Elev: 2000 ft.

JAMES R. SHEVOCK NUMBER: 2575

Within the "island" of California (California's coastal profile, mediterranean climate, plant diversity, and propensity for sheltering endemic species is analogous to an island's ecosystem) lives an even more specialized microgeography, the forests of the coast redwood, which thrive in a unique temperature and precipitation envelope. Working with different scenarios of greenhouse gas emissions, Hamilton and her colleagues work to project where this particular climate is likely to exist in the future. Their eventual goal is to seek protection not just for individual species, but also for geographical corridors through which species, reacting to changes in temperature, are likely to migrate. "Right now our entire hundred years of conservation strategy has been choosing a place, drawing a static boundary around it, and limiting negative human impacts there. That paradigm assumes a stable climate. Even now, species are moving out of areas where we have protected them. What is the strategy of a conservation manager at Joshua Tree National Park if all the Joshua Trees are gone from it?" Hamilton advocates delineating "continental wildlife corridors" that will allow for protection beyond static boundaries.

THE URGE TO EXPLORE

Evolutionary biologists have plenty to do back at the office: identifying and classifying specimens, painstakingly documenting them, and using both morphological and DNA characteristics to parse out where each organism fits on the tree of life. Yet contemporary systematists are no more office types than their nineteenth-century forebears. Botanists, ichthyologists, invertebrate zoologists—in their own way, each is addicted to the hunt.

Alfred Russel Wallace traipsed the globe, but these days the destination of an expedition is likely to be more focused. Hiking into remote natural areas—or wading and diving into their waters—scientists work day and night to collect, sample, record, and photograph what lives there. A critical component of their analysis is figuring out when species arrived at a place, and how. This is the intriguing puzzle facing scientists who periodically travel to two remote islands off the coast of West Africa in the Gulf of Guinea: São Tomé and Príncipe. Led by Dr. Robert Drewes of the California Academy of Sciences, scientists from a variety of disciplines have discovered a most amazing array of diversity endemic to these islands: Over half the forty-nine land-breeding birds there are found nowhere else. The same is true for 14 percent of the flowering plants (including the world's largest begonia, over six feet tall), 80 percent of the stag beetles, 60 percent of the terrestrial snails, and so on. One reason for this is that the islands are very old. Successful dispersal, long-term isolation, and thus evolution have had plenty of time to impact life there. São Tomé is seventeen million years old, and Príncipe is almost twice that, at thirty million years old. By contrast, the main Hawaiian Islands are five million years old.

Opposite: Also called the cobra lily, *Darlingtonia californica* is adapted to acidic bogs; it supplements its nitrogen requirements by digesting trapped insects. The living plant is green and translucent; insects that fly into its hood find themselves in a house of mirrors, a cape of apparent windows that would appear to be exits, but are not. The windows look skyward, so the insect seeking to escape flies up into them, encounters a waxy surface, and tumbles downward to the tubular part of the leaf. Let the digestion begin.

According to the received wisdom of much island biogeography, however, many of the species that have thrived on São Tomé and Príncipe shouldn't be there at all. For example, there are six unique frog species and a legless amphibian found only on São Tomé; their closest relatives live in East Africa, thousands of miles away and further separated by huge mountain ranges. As discussed earlier, amphibians are very poor dispersers, since salt water kills them quickly. Dr. Drewes's hypothesis is that long ago, these critters rafted down the Congo or the Niger on large terrestrial mats broken off from the shore by the force of these great rivers, both of which feed directly into the Gulf of Guinea.

As Dr. Drewes and many others ponder today's tangible evidence of an Earth history not yet told, they are racing against the clock—in this case, oil. The tiny republic of São Tomé and Príncipe, with a population of fewer than 200,000 people, includes areas in the Gulf of Guinea where this trump card of all commodities has been discovered. The solution to our modern appetites has pretty much always had a negative impact on wild areas, and the revenue, infrastructure, and population changes heading toward these tiny islands threaten what we all probably agree is their truly invaluable treasure: diversity beyond price. Dr. Drewes hopes to show the people of São Tomé and Príncipe the details of their unique heritage and thus help them make informed stewardship decisions down the road.

Opposite: It is very unusual for a new mammal to be discovered. Galen Rathbun and colleagues, however, recently discovered and named this elephant shrew, *Rhynchocyon udzungwensis*, from Tanzania. Only very distantly related to true shrews, the species behaves like a cross between a miniature antelope—they are very alert and flighty, and run on long, spindly legs—and a miniature anteater, foraging for invertebrates in leaf litter. Although they have been in Africa for about fifty million years, there are only seventeen living species; the reason remains an evolutionary mystery.

Overleaf: Holotype specimens are crowned the quintessence of their kind and are the standard-bearers for all subsequent identification of the species. The blue ribbons on this grouping of herpetological specimens from Burma signal their status. These holotypes are all newly discovered species.

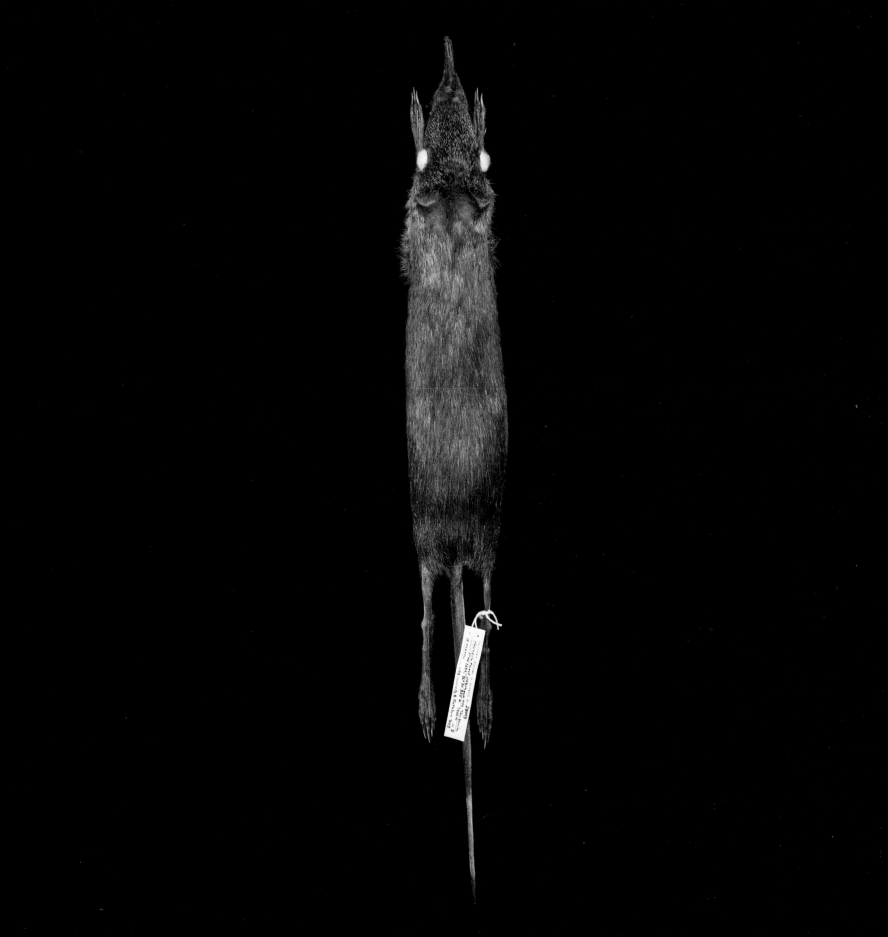

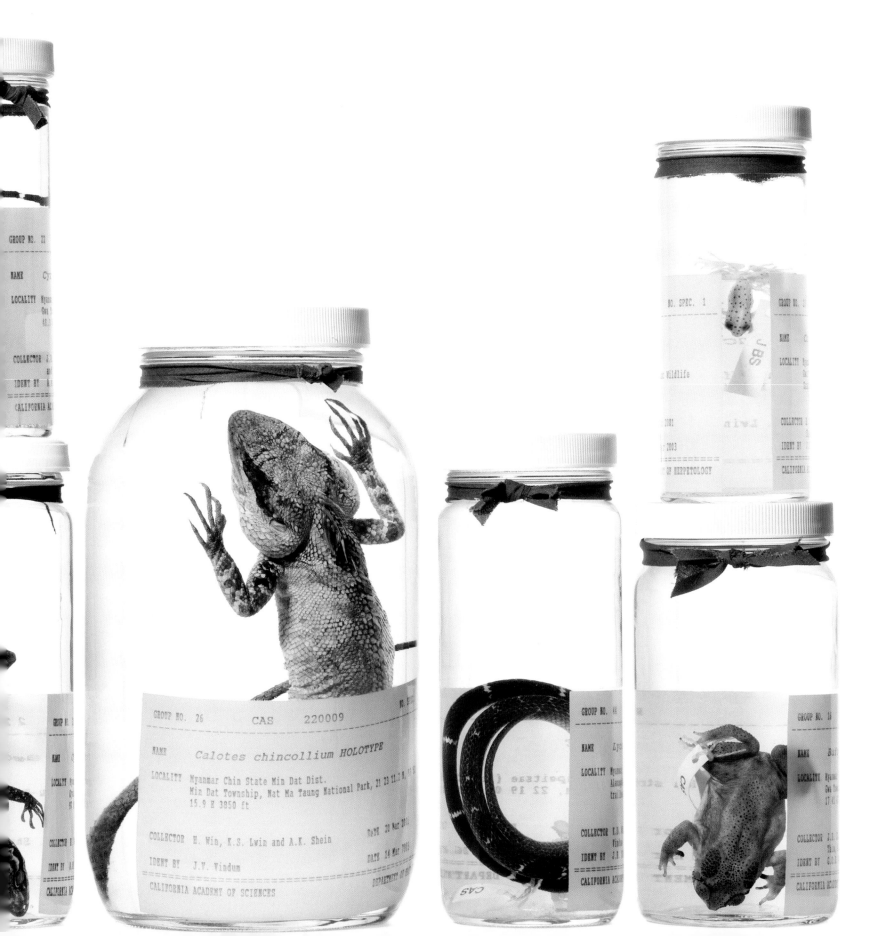

THE UNENDING SYNTHESIS

MOLECULAR INHERITANCE

Darwin posed it thus: How could slight changes in form, introduced over the course of many thousands of generations, produce different adaptations to different circumstances? At the same time that Darwin parsed out his broad, conceptual take on how life-forms change over time, Gregor Mendel was performing isolated, practical experiments on pea plants. Unknown to Darwin, Mendel's work remained obscure for nearly fifty years, but when it was rediscovered it provided the basis for explaining the mechanism of evolution: genetics (the word "genetic" is based on the Greek for "origin," which in turn is derived from *genno*, "to give birth"). Starting from the fact that all living things inherit traits from their parents, genetics explores how this occurs and what results.

Mendel's work grew out of his initial observation that pea plants had different morphologies: Some had purple flowers, some white; some had long stems, some short. When he bred the plants, he noticed that the offspring usually resembled one of the two parents. As he continued to breed the second and third generations of pea plants, traits that had disappeared during even several go-rounds reappeared, undiluted. Mendel's experiments showed that whether they are visible or not, heritable traits remain present and are passed from parent to offspring. We understand now that the basic unit of heredity is the gene, and that most organisms inherit two alleles, or different forms of the same gene, for each trait, one from each parent. Some alleles are dominant and some recessive, meaning that when they are inherited together the dominant one will be expressed. But the recessive allele will nevertheless be passed on in reproduction, and will show itself when it is again paired with the same recessive allele.

Well before the nuts and bolts of what exactly occurs in a gene were understood, scientists sought to understand whether Mendel's description of the mechanics of change and Darwin's description of the process by which change occurred are compatible—that is to say, whether environmental pressures drive progeny to inherit particular characteristics. For going on two hundred years now, the peppered moth has been a favorite example to illustrate the process of evolution in action. Originally, the peppered moth was a largely light-colored species, seeking camouflage against lichen-covered trees; during England's industrial revolution, pollution both poisoned the lichen and darkened the trees with soot. Populations of the light-colored moth, easily picked out by birds against the backdrop that had previously obscured them, were radically reduced. Populations of the dark-colored peppered moths increased. As air pollution was addressed and abated, the trees began to lighten again, and the light-colored peppered moth proliferated once more. Natural selection made a clear impact on the inherited alleles, favoring dark or light pigmentation depending on the environmental circumstance.

Nearly one hundred years later, scientists began to look further and further into the gene, discovering its molecular basis. In 1944, Oswald Theodore Avery, Colin MacLeod, and Maclyn McCarty identified the material responsible for inheritance as DNA; in the 1950s, using X-ray crystallography developed by Rosalind Franklin, James D. Watson and Francis Crick revealed the structure of DNA as a double helix: two strands connected by nucleotides in a twisted ladder. Composed of combinations of just four possible chemical bases—adenine, cytosine, guanine, and thymine—DNA

provides the instructions for every given trait passed from parent to offspring. Specifically, DNA's double strand provides the mechanism for copying genetic information: When the two strands are separated, the sequence of molecules—symbolized by letters—on one strand is used as a template to build a new strand; this is what happens in reproduction, as well as in the day-to-day production of the proteins that run an organism's metabolism. When there is damage or a mistake in the copying, the normal sequence of letters is altered and mutation occurs.

As these concepts became clearer, genetic inheritance seemed to knock natural selection out of the ballpark as an explanation for life. Genetics answered the question of inheritance and identity in terms of specific chromosomes discernible under a microscope. Eventually, however, contributions from a range of disciplines, including systematics and paleontology, resulted in "the modern synthesis," a term coined by Julian Huxley to express the relationship between genes and forms of life. Among other things, the modern synthesis defines evolution as natural selection acting on genetic variation. It also posits that macroevolution, evolution occurring at higher taxonomic levels where large groups of organisms diverge from one another, is the result of microevolution, or small genetic changes over longer periods of time.

Previous spread, left: The horseshoe crab is sometimes called a "living fossil," though contemporary species are only distantly related to their ancient forebears, with whom they share a unique morphology.

Right: The chameleon deploys its kaleidoscopic color capacity by expanding, shrinking, and moving cells containing layers of red and yellow pigments, as well as a reflective blue stratum and white melanin. This chameleon has been "cleared and stained" for better scrutiny of its skeletal structure.

UNITY AND DIVERSITY: EVOLUTIONARY DEVELOPMENT

To see diversity, we only have to look around, or even just down at our feet—everywhere there is a dense and tangled bank of organisms, microenvironments of complex, multistoried coexistence. Biochemistry shows us a commensurate uniformity in all life: From the lowliest virus to the most sophisticated Nobel-winning scientist, virtually every organic entity is encoded by some combination of those four genetic letters in DNA. Modern science shows that all life-forms are related, and traceable to a common ancestor. But how, exactly, did a fish fin become a human arm?

Darwin, working within the taxonomic tradition discussed in chapter one, was much influenced by Etienne Geoffrey Saint-Hilaire, who used the term "analogy" to describe correspondences between organs or features depending on common ancestry; following Owen's usage, we now say that such parallels are "homologous." Darwin wrote: "What can be more curious than that the hand of a man, formed for grasping, that of a mole for digging, the leg of the horse, the paddle of the porpoise, and the wing of the bat, should all be constructed on the same pattern, and should include similar bones, in the same relative positions?" Homologous structures were instrumental to Darwin in parsing out the idea of evolutionary relationships.

The connections among animal form, genetics, and evolution are the subject of a fairly recent branch of biology called evolutionary development, or "evo devo." Evo devo delves into what Darwin called "one of the most elusive" questions in biology, or how a simple egg develops into a complete organism. Embryology has been the "black box" where, mysteriously, genetic information becomes three-dimensional, living, breathing animals. Work in this field has shown that a single set of "tool kit" genes directs growth in the embryo, causing different sections of it to develop into one form or another. Moreover, evo devo shows that all body organization, from flies to humans, follows a similar building pattern, and that body parts like eyes and limbs are governed by the same genes in different animals.

A person's arm is homologous to a bat's wing and a horse's forelimb—all are instigated from the same area of the embryo, and each is located on the same place on the skeleton. (Although both insects and bats have wings, their development is initiated from different parts of the embryo; the bat's wings have more in common with the horse's forelegs, since they are two variations on the same point of development in the embryo.) Hugely different features in animals have been created using the same basic tool kit, along a homologous sequence. The same gene that instructs an insect's belly to develop tells the backbone to form in a vertebrate. Darwin's "descent with modification" has taken place right here, throughout the embryo, as appendages and every other feature of organisms have changed function, the same genes making changes that accumulate by turning genetic switches on and off at different stages of development.

Astonishingly, this tool kit capacity predates the Cambrian explosion that brought so much variety of form to life, suggesting that the capacity for variation and form preexisted the ecological conditions or event that instigated it. Great evolutionary change has not been the result of new DNA, as had been assumed, but by ancient DNA being used in new and different ways. Placing the history of change in form in a time dimension, science can actually trace our continuous connection with ancient forms, back through early mammals, back through *Tiktaalik roseae*, back through fish, and all the way back to the first multicellular organisms, who also possessed the tool kit genes. This simultaneous unity and diversity are what prompted Theodosius Dobzhansky, a pioneer in evolutionary genetics, to title an influential paper: "Nothing in Biology Makes Sense Except in the Light of Evolution."

EXTINCTION: THE END OF EVOLUTION?

We mostly use active verbs to describe what plants and animals do: They compete, mate, eat, migrate, and so on. But we hardly ever say they die, and instead use passive verbs or participles to indicate the state of those who are no more: They are "gone" or "become extinct." Again, island species particularly illuminate the workings of extinction—smaller populations are more susceptible to changes in their environment, more easily wiped out by invading species, and defenseless against changes in predators and diseases to which they don't have time to adapt. There is a limited gene pool on an island, shrinking the number of strategies available to meet new challenges. But our world is becoming more like a small island every day. The conditions leading to the extinctions of individual species are becoming more generalized, gathering steam, extending the reach of eventual impacts to more and more species.

The foreground of life on Earth plays out against a "background level" of extinctions that have pruned the branches on the tree of life as much as have the creation of new species. Darwin recognized that the pattern of diversity over time has twists and turns and holes in it; the fossil record, which would platonically limn a great chain of being, is missing many links, and not just because some organisms don't leave good fossils behind. There are currently up to forty million species on Earth, but somewhere between five and fifty billion have at one time or another existed. Species constantly struggle with and against one another and the environment, and are likely to lose out every five million years, which is the average span of species duration, give or take a million years. In addition, five major extinction events have defined Earth's history, including the Cretaceous, sixty-five million years ago, and the Permian, two hundred and fifty million years ago—these took out the dinosaurs and half the marine invertebrates, respectively. The mass extinctions, caused by catastrophic geologic events, seem to counter Darwin's

implication that those with the "fittest" genes survive; in these cases, bad luck trumped all. The rate of death far exceeded that of speciation; with population diversity decimated, whole networks of ecological interaction were relegated to oblivion. Speciation keeps on ticking, however, and eventually, after millions of years, diversity comes back up to previous levels.

The tree of life consists of branches that continue to branch, but these also terminate. If there were no extinction, the tree of life would not have end points on it, but each branch would continue in a dense arrangement of continued lineages. In this scenario, speciation would reach a limit and would have to stop. Natural selection would refine adaptation perhaps even to a greater degree than it does in our world, but evolutionary innovations like flight and eyesight would likely not have their day to emerge. Life-forms as we know them depend on the history of extinction.

Such an observation should in no way mitigate concern about or efforts to overcome the sixth great extinction in which we are currently participating. To the background rate of slow and steady extinction and the abrupt upheaval caused by geologic extinction events, add a loss of species in a time period and on a par with the mass extinctions and throw in a cause that could stop if only it would: *Homo sapiens*.

Habitat destruction is one of the prime causes of the mass extinction under way now. When you take one species out of an ecosystem, there is a cascading effect, and many more species are affected. Population biologist Paul Ehrlich famously likened extinctions to the removal of rivets from a jet plane: Who could know which rivet would be the last holding the plane together? And certainly, not all rivets are created equal. Current forecasts say that, at current rates, 31 percent of all amphibians, 12 percent of all birds, 20 percent of all mammals, and 4 percent of all fish and reptiles will be gone by the end of this century. Habitat destruction contributes to the snowball effect of climate change by eliminating the very organisms that keep the atmosphere livable: plants. Plant life sequesters carbon dioxide and creates oxygen; its activity moderates the climate—no matter how virtual our world has become in many respects, we still need to breathe.

Darwin observed that the very adaptation that gives a species its edge could simply reach the end of its usefulness. *Homo sapiens* have proved fabulously successful partly due to our ability to sequester and control natural resources; this inclination has been magnified by our social and group dynamics, resulting in greater cooperative efficiencies perpetrated by corporations and governments. Our intellect and tool-making abilities far exceed those of any other species, but our very sophistication has brought us to a breaking point. Jonathan Weiner, author of *The Beak of the Finch: A Story of Evolution in Our Time*, observes that other species have created tremendous disruption by becoming ecologically dominant, but never before has this occurred "through the advent of a conscious dominant like ourselves, a conqueror come to watch." It may be that our consciousness is not quite up to the compliment.

Carl Jung observed Anasazi-Pueblo Indians who believed that by watching the sun they caused it to rise; he concluded that they enjoyed a primal connection to creation that had become buried and obscured in modern life. Perhaps we have an instinctive resistance to reframe "what I am doing is surviving" into "what I am doing is destroying," but waking to the reality of responsibility could restore our connection to the creation on a par with the sunrise-watching Native Americans. To a great extent, we now hold in our hands what was previously nature's power to decide whether a species becomes extinct or not. When an environmental impact report is shuffled through a bureaucracy, it should be understood that its consequences are not just local—it is a matter not of a single owl or beetle being lost, but entire worlds that impact on other worlds. Evolution's root meaning, "to unfold," can imply successive, rippling losses as well as ongoing life.

Page 108: Though they were at one time plentiful and collected as mounted skeletons, the Great Auk, *Pinguinus impennis*, is now extinct. Very few discrete sets of Great Auk bones exist anywhere today, and most remains, like these, are composites of bones found near each other on Funk Island, near Iceland.

Page 109: The Carolina parakeet, *Conuropsis carolinensis*, was hunted for its feathers and considered an agricultural pest. Its eventual extinction was probably due to loss of habitat, as old-growth forests were decimated on the East Coast. The last flock was sighted in 1920, in Florida.

Page 110: The labeling on this extinct *Potentilla multijuga* is a narrative in itself, telling the story of the various scientists who have studied it, in some cases adjusting the nomenclature describing the specimen. The Dudley Herbarium stamp is a relic of Stanford University's past: In the 1960s and early 1970s, taxonomy went out of scientific fashion, and Stanford donated its 850,000 herbarium specimens to the California Academy of Sciences. More recent molecular work has renewed the glamour of traditional systematics, enhancing the value of the specimens.

Page 111: The "Good God Bird" was so called because its magnificent mien caused its viewer to shout, "Good God, what is that?" Another victim of the loss of old-growth forests in the American South, stalwart lovers of the Ivory-billed Woodpecker still mount elaborate expeditions in pursuit of them. It is probably extinct.

Page 112: San Francisco's Golden Gate Park is a verdant stretch of woods, lawns, and gardens, inviting the populace to enjoy nature. Yet, the building of the park likely caused the first North American butterfly extinction due to human actions. The naturally occurring sand dunes under the park were home to the Xerces, in the Lycaenid family of butterflies, a breed known for its fifteen-million-year history of mutual interaction with ants. Native ants protected the butterflies in their larval stage from parasites and predation; in return, the butterfly larvae secreted amino acids and carbohydrates that served to nourish the ants. An Argentine ant was introduced to the area during the time the park was built. It wiped out the native ants, and thus followed the Xerces that depended on them.

Page 113: Passenger pigeons were once multitudinous; a source of cheap food for immigrant labor, they were hunted to extinction by 1914.

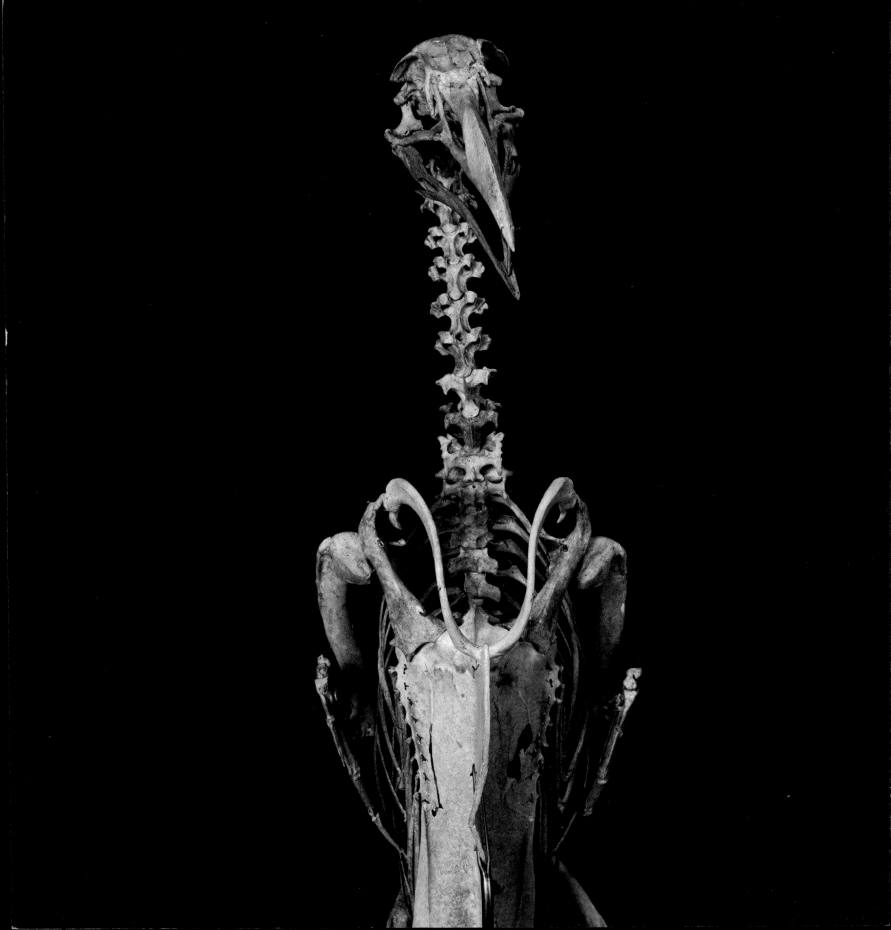

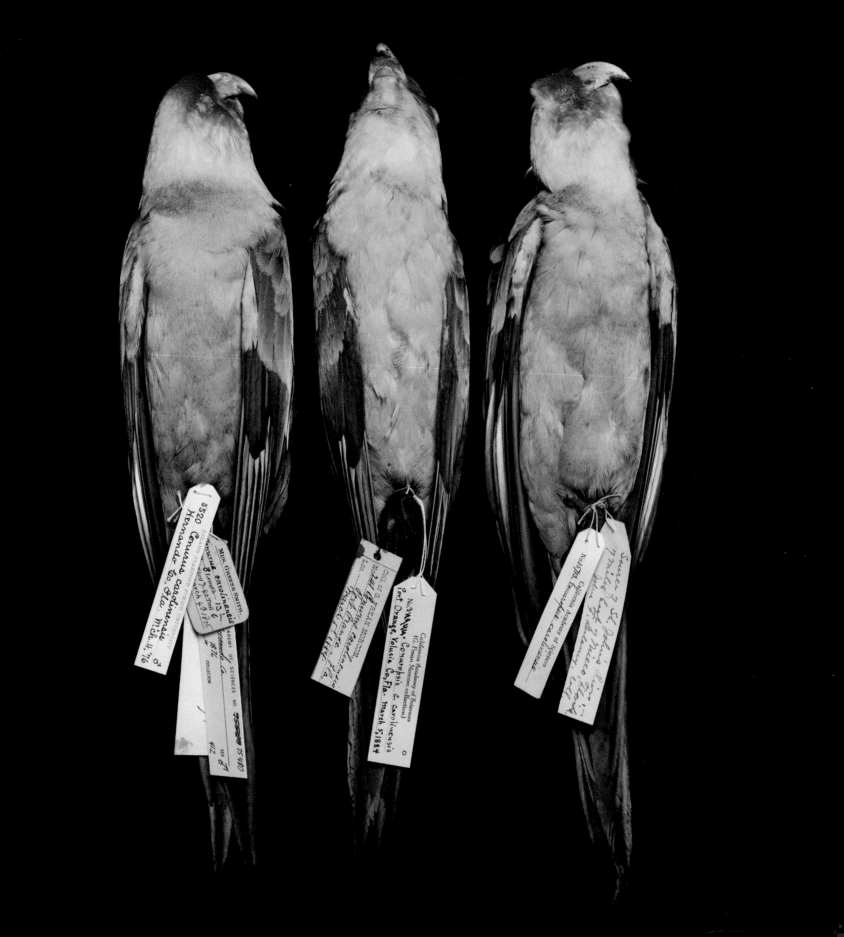

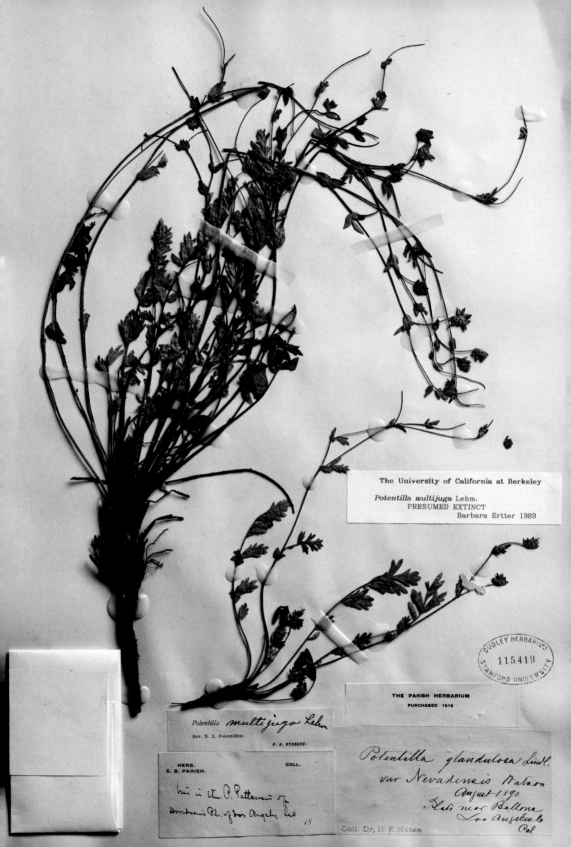

The University of California at Berkeley

Potentilla multijuga Lehm.
PRESUMED EXTINCT
Barbara Ertter 1989

THE PARISH HERBARIUM
PURCHASED 1916

Potentilla multijuga Lehm
Rev. N. A. Potentilleæ.
P. A. RYDBERG.

HERB. COLL.
S. B. PARISH.

his is the P. Patterson of
Dunton's Fl. of Los Angeles co

18

Coll. Dr. H. E. Hasse

Potentilla glandulosa Lindl.
var Nevadensis Watson
August 1890
Flats near Ballona
Los Angeles co
Cal

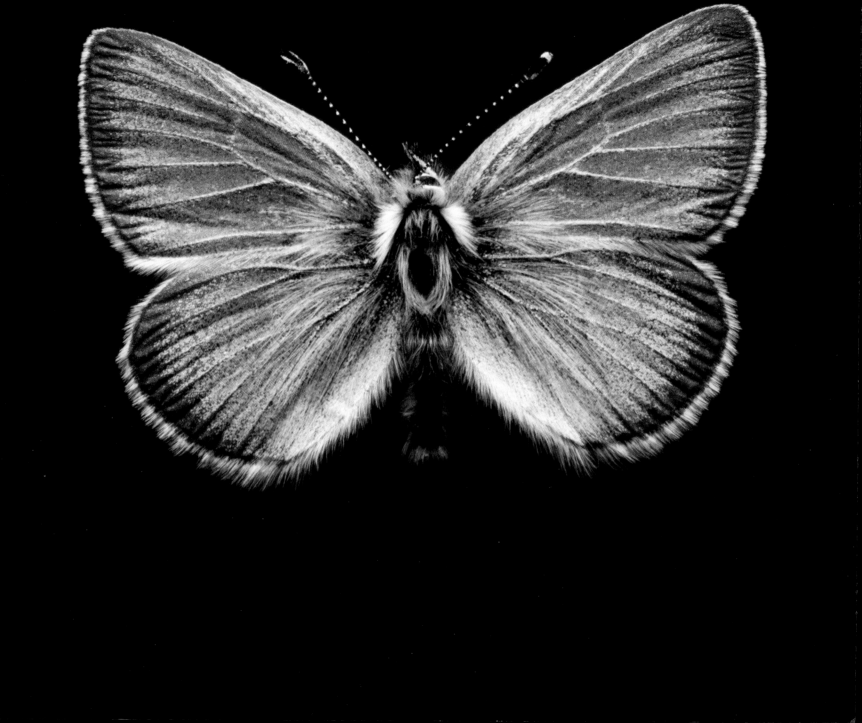

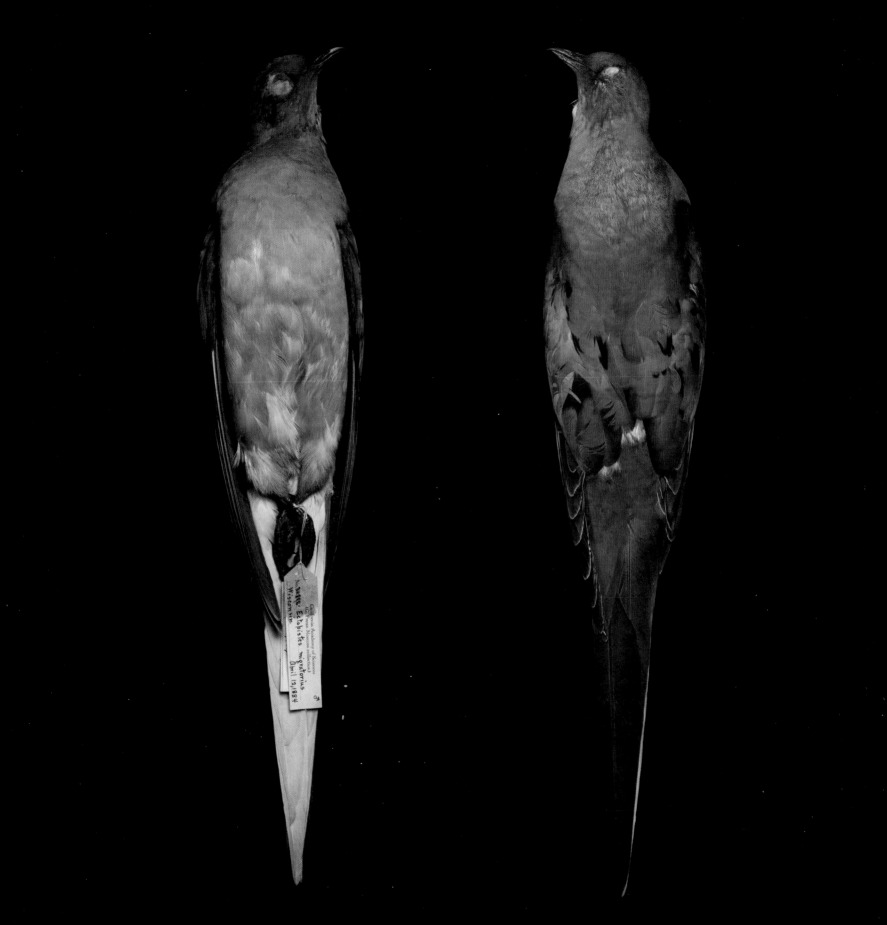

TO HOLD
THE MIRROR
UP TO NATURE

Arguably, Adam of Genesis, given the task of naming "every living thing" by his boss, is the first taxonomist. His job was not simply to keep an inventory, but to establish human stewardship of creation. Naming has become ever more complex and specific; the binomial ranks established by Linnaeus have been expanded into a larger hierarchy including families, classes, and kingdoms. We think of naming as a specification—in biology, to name an organism is to assign it a place in the time-frame of evolution and to connect it to every other organism, past and present.

The not-so-simple act of naming is the ground zero of knowledge about nature. As Dr. John McCosker of the California Academy of Sciences likes to put it, "you need the noun before you can employ adjectives and verbs to tell the story" of a specimen. And as such, taxonomical naming is the first step to take in the effort to save life on Earth. As discussed earlier, biologists go to so-called ecological "hot spots" to catalog unique assemblages of flora and fauna because we have to know what we stand to lose when those environments are compromised. Further, not all species are created equal, and we can't save everything. Conservationists characterize the current state of affairs as "triage": Like surgeons on a battlefield, biologists have to sort casualties and prioritize what species to save in order to maximize total survival.

Since conservation efforts work within a context of development to support growing populations, some biotas have to be selected for protection over others. How to choose? First of all, by knowing what exactly is located where. Second, by having solid information about a species' ancestry, persistence, and radiation. The coelacanth, for example, is an impressive fish dating in the fossil record to the mid-Devonian period. Long thought to be extinct, a coelacanth was pulled out of a shark-gill net off the coast of Africa in 1938, and several more have periodically been captured. With an ancestry that has survived mass extinctions and climate catastrophes, the two extant species of coelacanth are more valuable to conserve than, say, a species of shark that radiated recently and is closely related to a whole host of other sharks. Within the coelacanth are traits shared by an ancient common ancestor, characterizing perhaps the very elixir of life and some protean capacity for survival, as well as evincing a deep connection to early life on Earth.

Damien Hirst's famous artwork, a thirteen-foot-long, full-grown tiger shark titled *The Physical Impossibility of Death in the Mind of Someone Living*, may menace us with suspended mortality, but by comparison, a coelacanth specimen has an even more primal story to tell. Specimens are relics, containers of meanings conferred in a long dialog, not about what life means but about what life actually is: They embody the evidence of time and change. In pointing backwards to previous forms and relationships, and forward to those yet to come, specimens transcend this moment of knowledge and make way for the future of it.

Opposite: Anthropologists like to say that to see evidence of human evolution, you should look in the mirror. Another ponderable is the close relationship of humans to chimpanzees, with whom we share over 98 percent of our DNA.

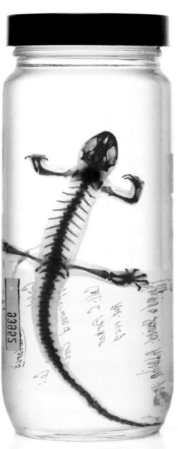
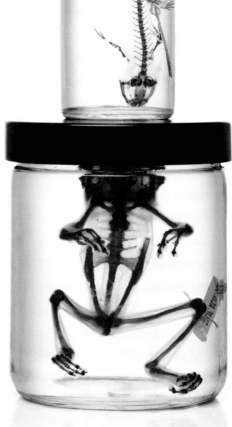
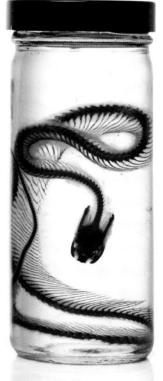

PHOTOGRAPHER'S NOTE

All of the photographs in this book are of specimens from the research collections at the California Academy of Sciences in San Francisco. Founded in 1853, it is the oldest scientific institution west of the Mississippi. The museum has been recently reincarnated in an impressive new "green" building designed by Renzo Piano, housing an array of public exhibits and, hidden from public view, a world-renowned collection comprising over twenty million specimens. These are organized by departments: herpetology, entomology, ichthyology, botany, invertebrate zoology and geology, ornithology and mammalogy, anthropology, and aquatic biology. I gained access to the inner sanctum of the museum to make these photographs. Setting up a temporary studio, I began my search—with the guidance of the curators and collections managers—to select specimens that would illustrate some aspect of evolution and convey an impression of the diversity of life documented in the collections.

Every specimen has an evolutionary story. Fossils can be remarkably precise depictions, documenting life-forms with great acuity. In this way they are similar to photographs; inherent in each is the power to record an image in an instant. Some of the photographs in this book show specimens collected over a hundred years ago, such as those from the California Academy of Sciences' 1905–06 Galápagos Expedition, and others have been recently accessioned, such as the colorful snakes from Myanmar Province in Burma, which were collected during summer 2008. Sometimes I removed a specimen from its scientific context, as with the grouping of murre eggs; other times I have purposefully retained that context to help visualize the process of taxonomy. There are traditional "study skins," which is typically how birds and mammals are preserved and stored. I've also included lifelike taxidermic specimens for their visual dynamism and because they represent another way that specimens have been preserved.

I photographed specimens of plants and animals that have gone extinct; they are all that is left, and they can tell us something about what once was. These specimens are usually stored in specially designated locked cabinets with enhanced protection protocols. Equally valuable are the "type" specimens, which are individually selected to be the tangible representations of their species corresponding to the formal written species descriptions. There is only one holotype of any given species in the world. Several of the images show species that have been recently discovered and are new to science, illustrating that all is not known in the natural world. There remains much to be discovered.

The daunting reality of twenty million specimens dictated that the search for photographic subjects could not be exhaustive. The specimen selection was guided by suggestions from the scientists, discussions with my coauthor, Mary Ellen Hannibal, my own research, and what caught my eye. I want to convey the diversity and complexity of life as embodied in the collections and to shed some light on why these plants and animals are the way they are, how they fit into the evolutionary puzzle—and to communicate the wonder of life itself. I hope the photographs transmit some of my own intrigue and amazement when I see these specimens and learn something of their meaning. They are portraits of preserved animals and plants, dead stuff, but I look for something expressive in them, and I've tried to capture that in the photographs. I also see them as reflections of the scientists who collected and prepared the specimens with such precision and care, and the unrelenting human propensity to organize and categorize our world.

—SUSAN MIDDLETON

Opposite: In the practice of clearing and staining a "wet" specimen, a red dye is applied to highlight the skeleton or a blue dye to highlight the cartilage.

Overleaf, right: Let the philosphers decide whether mimickry has an aesthetic value; the butterfly on the bottom poses as its poisonous bretheren on the top, and so makes of survival, an art.

INDEX OF SCIENTIFIC NAMES

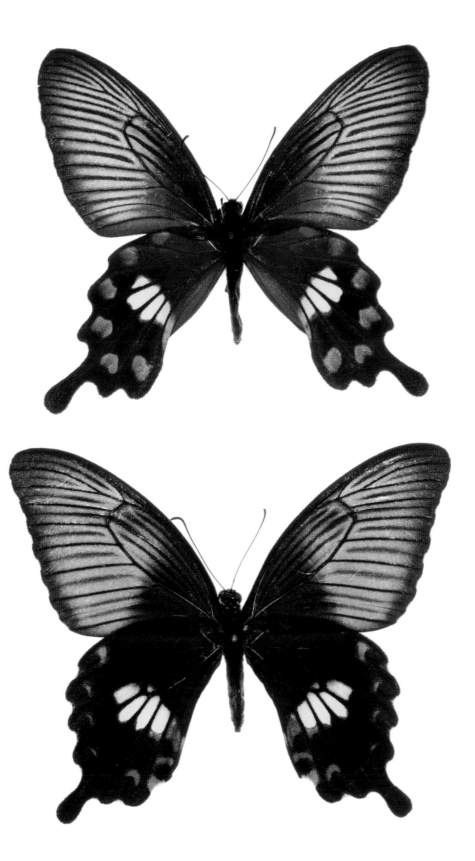

INDEX

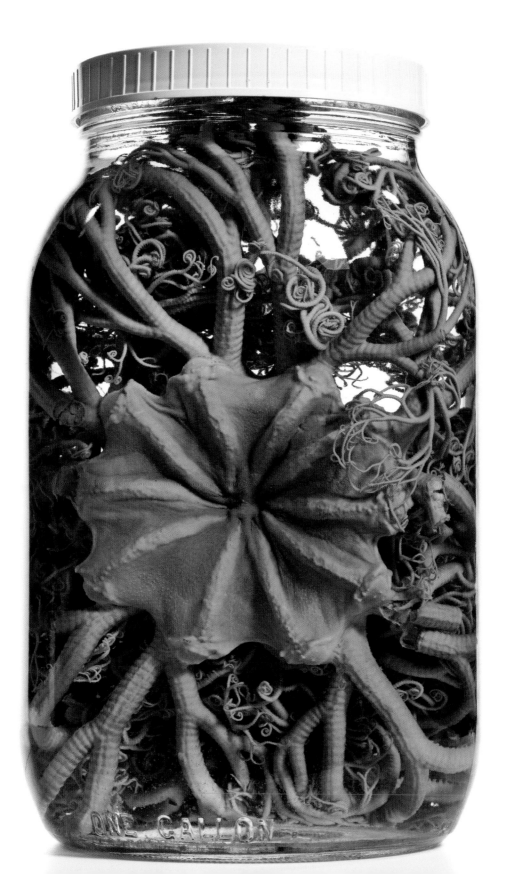

ACKNOWLEDGMENTS

As evolution unfolds, so did the progress of this book, beginning with Pat Kilduff; when I went to Pat with my idea for a book about evolution based on the Academy's specimens, she said, "I'll make it happen." And she did. Special mention goes to Frank Almeda, Mike Ghiselin, John McCosker, and Rich Mooi.

—MARY ELLEN HANNIBAL

I am especially grateful to Frank Almeda for facilitating my work at the Academy and providing me a space to work; Geneva Bumb Shanti for her expert assistance with the photography; Bob Tamura, Joe McDonald, and Mark Mather for getting me equipped; Brent Jones for helping me visualize the book; Raymond and Akmene Bandar for warm hospitality and bone loans. Special thanks to Rich Mooi for the echinoderm story; Bob Van Syoc for the cephalopod story; and Moe Flannery for sorting out the finches.

—SUSAN MIDDLETON

At Abrams, it has been our pleasure to work with Eric Himmel, whose special passion for science is felt on every page, and the unflappable Eric Klopfer. Presented with the task of integrating three distinct ways of conveying meaning—photos, text, and descriptive captions—designer Kwasi Osei created a book of beauty and purpose.

We would both like to express gratitude to the California Academy of Sciences, with deep appreciation for the many people who explored, discovered, collected, prepared, and continue to maintain the specimens shown in this book:

Zeray Alemseged
Frank Almeda
Barbara Andrews
Roberta Brett
Dave Catania
Tom Daniel
Jean Demouthe
Robert Drewes
Jack Dumbacher
Greg Farrington
Jean Farrington
Brian Fisher
Moe Flannery
Michael Ghiselin
Terry Gosliner
Healy Hamilton
Tomino Iwamoto
Dominique Jackson
Dave Kavanaugh

Linda Kulik
Al Leviton
John McCosker
David Mindell
Becky Morin
Rich Mooi
Wendy Moore
Larry Penny
Norm Penny
Rebecca Peters
Charlotte Pfeiffer
Wojciech Pulawski
Peter Roopnarine
Jere Schweikert
Debra Trock
Bob Van Syoc
Jens Vindum
Barbara West
Jeff Wilkinson

Opposite: Basket stars are another of the Echinodermata. Like starfish and sand dollars, they posses a water vascular system, evident in their five-part symmetry. These beautifully curling and complex dendritic structures are actually true arms; they divide, and divide again and again, until an exponentially increased number of end points form the organism's suspension-feeding "basket."

Arctostaphylos hookeri G. Don
subsp. ravenii P. Wells
det. T. Daniel, 1998

3972.

PLANTS OF CALIFORNIA

Arctostaphylos franciscana Eastw.

Prostrate on windswept slopes,
c. 400 ft., above Baker's Beach,
San Francisco. One shrub.

Peter H. Raven April 10, 1952.

Cited: Howell, Raven, and Rubtzoff
Wasmann Journal of Biology 16: 111. 1958.
(Flora of San Francisco, California)

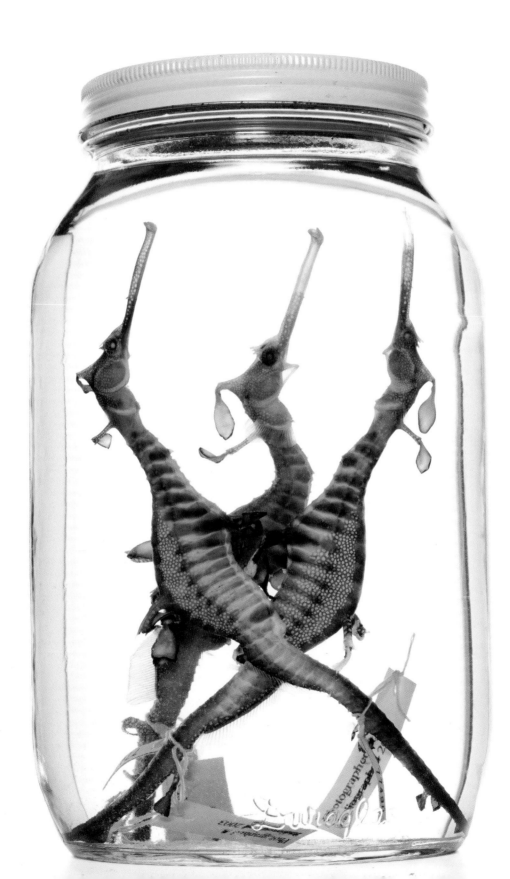

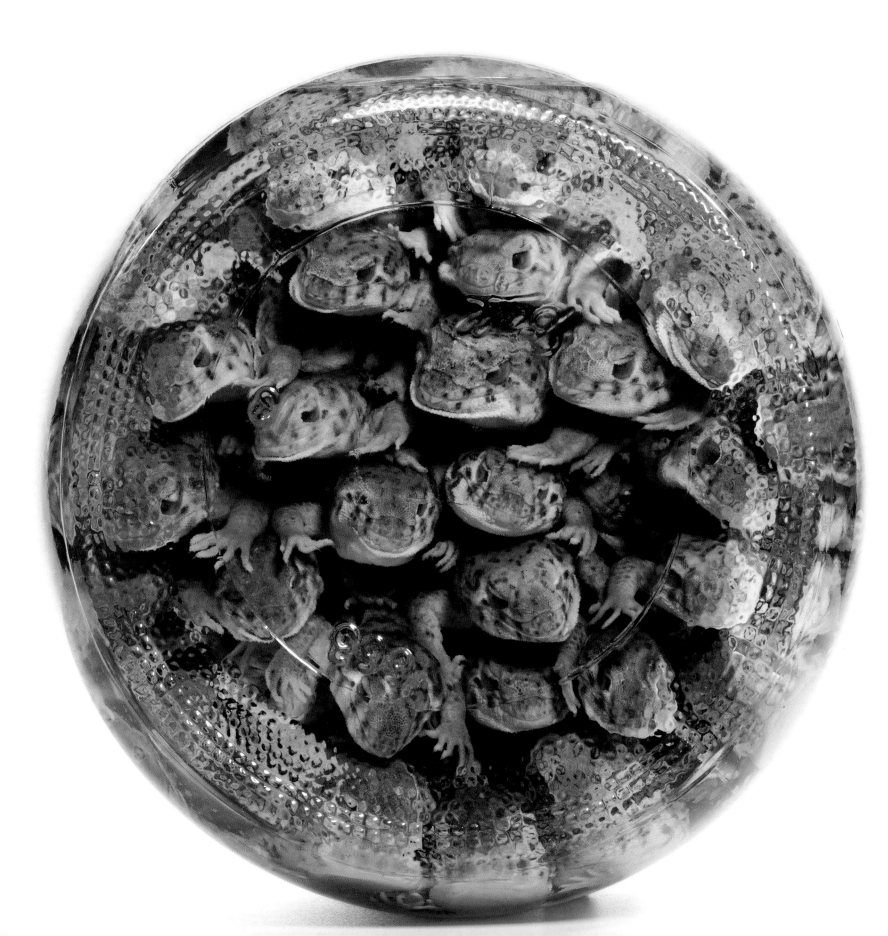

Editor: Eric Klopfer
Designer: Kwasi Osei
Art Director: Michelle Ishay
Production Manager: Jules Thomson

Library of Congress Cataloging-in-Publication Data

Middleton, Susan, 1948–
 Evidence of evolution / photographs by Susan Middleton ; text by Mary
Ellen Hannibal.
 p. cm.
 ISBN (hardcover) 978-0-8109-4924-9
 ISBN (paperback) 978-0-8109-8846-0
 1. Evolution (Biology)—Pictorial works. 2. Evolution (Biology)—Popular
works. I. Hannibal, Mary Ellen. II. Title.

 QH367.M594 2009
 576.8—dc22

 2009004652

Printed and bound in China
10 9 8 7 6 5 4 3 2 1

Abrams books are available at special discounts when purchased in
quantity for premiums and promotions as well as fundraising or
educational use. Special editions can also be created to specification. For
details, contact specialmarkets@abramsbooks.com or the address below.

THE ART OF BOOKS SINCE 1949
115 West 18th Street
New York, NY 10011
www.abramsbooks.com

Previous spread, left: A single Raven's manzanita in
California's Presidio is the last of its kind in the wild; clones are
being cultivated in the nearby San Francisco Botanical Garden.

Previous spread, right: Sea horses are the ultimate aquatic
shape-shifters. They have completely changed the fish body
plan, making it vertical instead of horizontal and turning their
heads to a right angle. Their tail has dropped and become
prehensile, like a monkey's—gently approached, a sea horse will
wrap its tail around your finger. These "weedy" sea dragons don't
so much resemble the archetypal Hippocampus species as they
do the surroundings in which they hide.

Opposite: Taxonomists collected multiple *Teratoscincus
roborowskii* specimens to help establish the parameters of
diversity that define the species.

Overleaf: Germain's Peacock-Pheasant. The process
underlying the development of feathers in birds produces
all other epidermal structures, including scales, hair, and even
mammary glands. Evolutionary development demonstrates
the unity among even the most various of forms.

Front endpaper: The only known animal in which the male
gives birth, sea horses are endangered all over the world due to
habitat loss and overcollection.

Back endpaper: The deeply crevassed edge shown in these
African *Heliphora urbiculus* sand dollars has coevolved in
completely unrelated species.

127

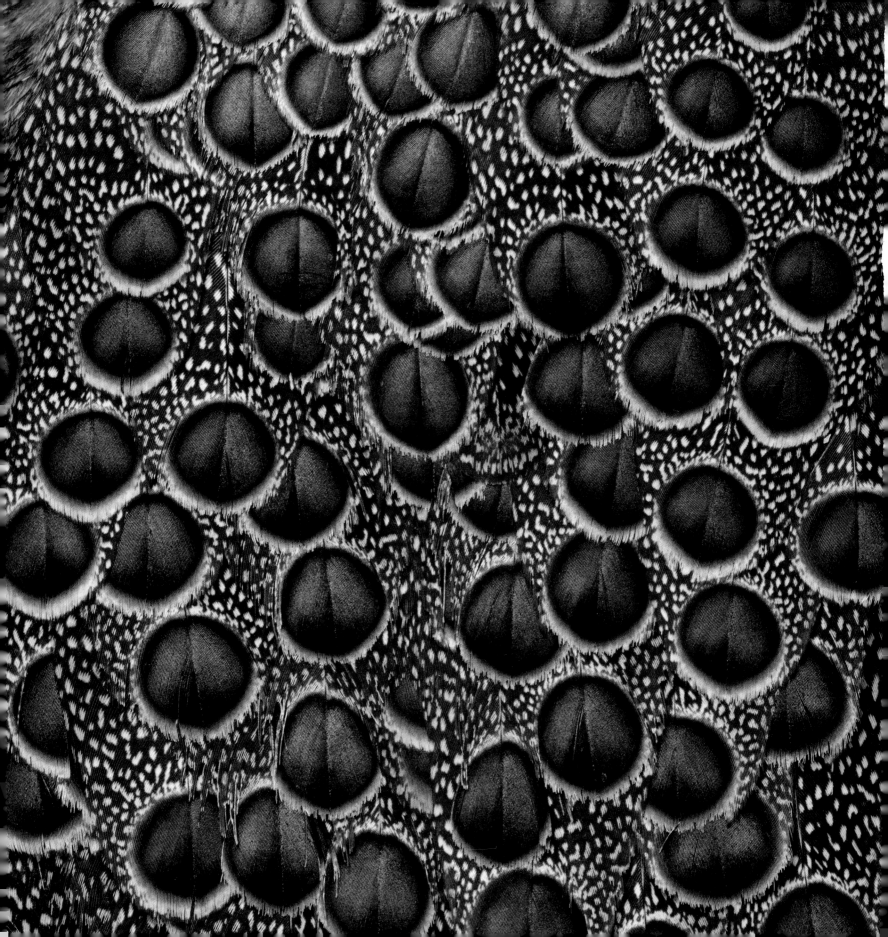